THE BRITISH LANDSCAPE

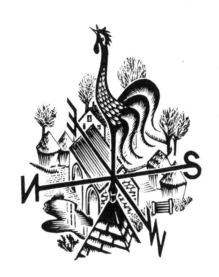

IAN JEFFREY

THE BRITISH LANDSCAPE

1920–1950

with 150 illustrations, 50 in colour

THAMES AND HUDSON

For Christina

ACKNOWLEDGMENTS

I am greatly indebted to everyone at the Fine Art Society for their help on any number of matters, and to the librarians of the Tate Gallery and the Victoria and Albert Museum. The Arts Council Collection is a treasure trove, and the compilers of its catalogue have my heartfelt thanks. Those who serve in the print room of the Victoria and Albert Museum were unfailingly helpful. Jonathan Blond of Blond Fine Art gave aid when it was needed, as did the staff of the Art Department at the British Council. I would also like to thank these individuals for information and advice received: Sir Brian Batsford, Nicola Bennett, David Brown, Kay Chaloner, Lise Connellan, A.J. Cumming, Clifford and Rosemary Ellis, Robin Garton of the Robin Garton Gallery, Anne Goodchild, Gill Hedley, Rodney Hillman, Carol Hogben, Charles Knight, Michael MacLeod, Dr David Mellor, Richard Morphet, Adrian Orchard, David Wright and Frances Spalding who made such a major contribution to our Arts Council exhibition (*British Landscape 1850–1950*) and who brought so many of the finer pictures to my attention. I.J.

Page 1. Margaret Webb, wood engraving from John Claridge,
The Country Calendar, 1946.

Printed and bound in Great Britain by
Balding and Mansell Limited, Wisbech.

CONTENTS

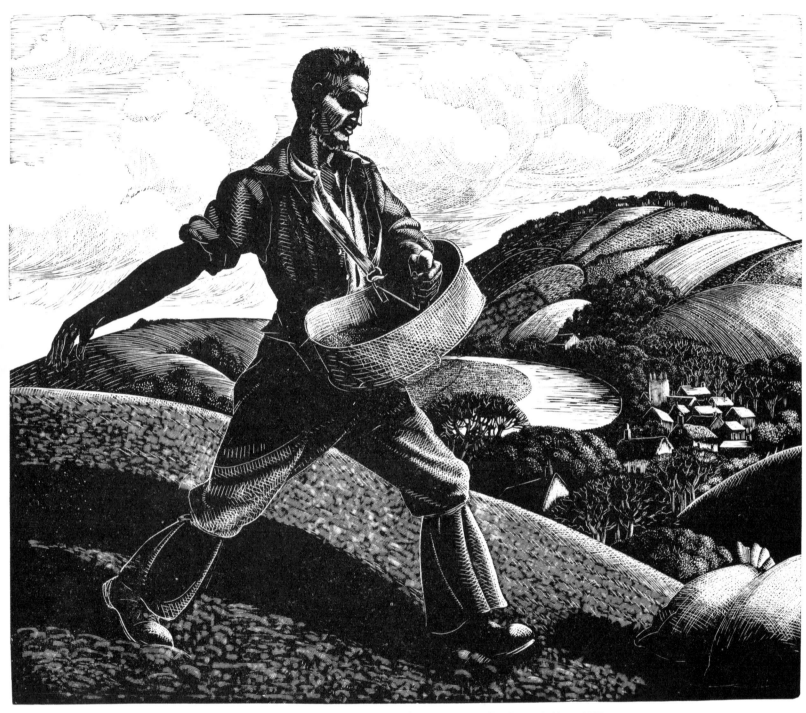

Clare Leighton, *April*. Illustration from Clare Leighton, *The Farmer's Year*, 1933.

INTRODUCTION

Between 1920 and 1950 British landscape art changed quite fundamentally, although not beyond recognition. During the 1920s, while memories of the Great War were still vivid, artists and writers envisioned Britain sometimes as a pastoral haven and sometimes as a multi-coloured pleasure garden. They continued to do so during the 1930s, although at the same time new images of landscape were established: in these the countryside increasingly featured as an orderly, worked terrain of farmland and quarry. As if in opposition to this orderly impulse, artists of the 1940s placed a new stress on rural Britain, although it was now to the wilder nature of mountains, forests and rocky shores that they turned. The rocks and stones and trees of Neo-Romantic painting gradually gave way in turn to the brick walls and back gardens of a new kind of Realism which came into being during the later 1940s and flourished in the 1950s. In short, the history of landscape art in these decades is a history of constant negotiation between pastoral and modernizing tendencies, with the pastoral usually in the ascendant.

That is the basic outline of a story which includes any number of episodes and sub-plots, as well as an especially diverse and interesting cast. Despite its variety, however, there are certain fundamentals which can be established. In the first place, although British landscape art was founded on affection for the countryside, it was not necessarily a disinterested affection springing solely from exposure to a perfect land. There was often a background of disquiet, of threats to be countered and of fears to be allayed.

The threat varied according to the age. In the 1920s, and for much of the 1930s, it was retrospective, and was constituted of nightmares implanted in the British psyche during the Great War. These were supplemented by a loathing of the 'dark, Satanic mills', still functioning in the North and in the Midlands, and by an unease regarding Abroad, a boundless, anarchic *terra incognita*. These dark dreams made Englishmen especially appreciative of what the poet Ivor Gurney described as those 'tiny, dear places – orchards, roads winding through blossomy knolls', as he remembered his native Gloucestershire in a letter from the trenches in March 1917. More persuasive and more immediate, though, was the threat embodied in modernization which seemed likely to establish so many new roads, new suburbs and new golf courses that the old

agricultural landscape would be obliterated within the foreseeable future. Fears for the future of the countryside were at their strongest in the 1930s, and they were most strikingly articulated by polemical essayists such as G. K. Chesterton, C. E. M. Joad and Guy Chapman.

Certain artists in the 1930s, on the other hand, were attracted by modernist forms and sought to place them in a landscape context: Paul Nash, Ben Nicholson and John Tunnard were especially interested in this problem. However, the idea that comes across most strongly during all three decades, and which will be discussed here, is that love of landscape and fears for its future masked a deeper concern regarding the maintenance of personal space and a sense of self.

One of the first questions likely to strike anyone looking over the landscape art of these three decades concerns the comparative rarity of Sublime or Heroic landscape. For example, one of the major and isolated achievements in British art just before the Great War was that of Philip Wilson Steer, who in the years 1905–10 had painted outstanding landscape oils of Chepstow Castle, the Severn Valley and the Isle of Purbeck. In these the land is fused with and animated by light and weather, ennobled by association with the sky. D. H. Lawrence, a tyro writer in the years when Steer was at his peak, found an equivalent for such painting shortly afterwards in the opening pages of *The Rainbow* (1915): 'In autumn the partridges whirred up, birds in flocks flew like spray across the fallow, rooks appeared on the grey, watery heavens, and flew cawing into the winter.' Lawrence described an animated meadow landscape which preceded and inhabited the lives of his characters. It was about twenty years before that spirit re-emerged in the Provençal paintings of Matthew Smith, and in the sweeping lines of David Bomberg's landscape drawings. A late, and equally isolated achievement in this vein was that of Paul Nash: *Landscape of the Vernal Equinox* (1943), for example, and *Landscape of the Malvern Distance* (1943). In this art of sun and moon, downland, flowers and forest, Nash had meanings in mind: 'Now I am re-opening my research – renewing the solution of the problem of light and dark and half-light', he wrote in 1943. But his programmes were tentative, obscure even to himself, mere indications of the grandeur which he achieved in paint. After working for more than twenty years in a manner which accommodated nature and culture, the organic and the inorganic, he achieved at last an elemental art quite at odds with the constructed look of his earlier painting. Such sublimity was hard to countenance in that it tended towards the belittling, if not the annihilation, of the artist.

A questioner puzzled by the intermittent and hard-won appearances of a Sublime landscape art might be just as intrigued by the irregular progress of Objectivism in these years. In the years just before the Great War, the Camden Town painters, especially Spencer Gore, Harold Gilman and Michael Ratcliffe, had charted the squares and back gardens of London as seen from their studio windows. Appreciative

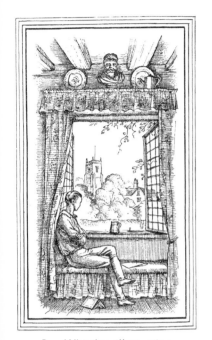

Rex Whistler, illustration from Beverley Nichols, *A Village in a Valley*, 1934.

John Minton, *The Great Snow*. Illustration from H. E. Bates, *The Country Heart*, 1949.

8

of good order, they relished tabulated scenery marked out by pathways, trimmed hedges, posts and iron railings. Gore died in 1914 and Gilman in 1919. Charles Ginner, their contemporary and co-founder of the Camden Town Group, worked on in the original exacting manner through into the 1940s, but he adapted his style and in his later window pictures stood back from the sill in a way which emphasizes the artist's viewpoint. Walter Sickert's inter-war exercises in the same mode were also saved from impersonality by an extravagant irony which applied exotic titling to the plainest material. Otherwise this very objective style was hardly used, for although it brought the visible world within reach and showed it to be manoeuvrable, it did so with such impersonality that the artist became more artisan than originator.

Norman Hepple, illustration from Mary Webb, *The House in Dormer Forest*, 1931.

Most artists wanted neither to become recording instruments nor to lose themselves in nature. Nor on the other hand did they want to be assimilated into the culture at large. To preserve a sense of an independent self was the aim, and this entailed both a search for places away from the mainstream of modern life and the use of forms suggestive of privacy. Although the Camden Town artists painted park and garden landscapes from the windows of their studios in the city, and although David Jones drew the packaged back gardens of South London from a window in his parents' house in Brockley, the seclusion of country towns, villages, farmsteads and cottages was very much preferred by a majority of artists.

This drift to the land was not entirely, nor even largely, due to a disinterested love of the earth and the changing seasons. Artists' country, in the 1920s and 1930s especially, was more a matter of cottage and farmland than of wilderness and wood. There were practical reasons for this. In the summer of 1930, for instance, Frances Hodgkins wrote to her dealer from Flatford Mill at East Bergholt in Suffolk: 'It has poured most days lately and I have been painting thunderstorms from the many windows of the old Mill – These windows are a Godsend & do away with some of the practical horrors of working out of doors in this weather.' Soon afterwards she complained of loneliness when living in a cottage at St Osyth in Essex and looked forward to going to stay with friends at Wilmington, Sussex: 'They have a farmhouse – cottage – warm cheery and congenial.' Writing to his friend the poet Gordon Bottomley in 1927, Paul Nash described his new cottage at Iden in Sussex as 'both a garden house and a ship to live in, full of sun and wind.' Thus a house, or cottage, functioned like an outpost in nature; it gave both access and assurance to artists who were themselves often far from adventurous.

The countryside, with its cottages and farms and protective woodlands, was cherished for very good reasons. It stood for everything that had been under savage threat during the Great War, and consciousness of that war was never far away during the 1920s and 1930s. It dominated living memory, and was the subject of a series of distinguished war memoirs headed by Edmund Blunden's great elegy *Undertones of*

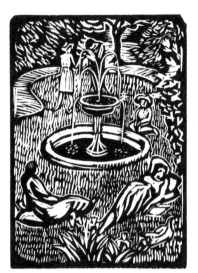

Roger Fry, *Fountain in a Garden*. Woodcut, 1922.

War, first published in 1928. Behind every comforting image of garden, farmyard and sheltering valley represented in the art and letters of these two decades lay memories of Sanctuary Wood, Passchendaele Ridge, Slime Street, the Spoil Bank and a thousand other desolated sites, all of which were regularly recalled, especially in the 1930s, in commemorative books and articles, reminders of and warnings against a disastrous militarism.

The Great War had many meanings. In retrospect, most British writers thought of it elegiacally, as a time when they had come to consciousness of the earth's beauties; none invested it with the sheer meaninglessness which the French writer Céline evoked in *Journey to the End of the Night*, first published in English in 1934. To war artists and topographic photographers who had recorded the landscape of Flanders, it meant, on the other hand, a boundless, uncomposed landscape of sky, a level horizon and disturbed earth marked here and there by the stumps of stripped trees. In a memoir of 1929, *No Enemy: A Tale of Reconstruction*, the novelist Ford Madox Ford described himself at the Front dreaming of an ideal landscape: 'Not quite a landscape; a nook, rather; the full extent of the view about one hundred seventy yards by two hundred seventy – the closed end of a valley; closed up by trees – willows, silver birches, oaks and Scotch pines; deep, among banks; with a little stream, just a trickle, level with the grass of the bottom. You understand the idea – a sanctuary.'

His artist contemporaries, even those who knew of the war only at second hand, were just as charmed by the magic of such secluded places. Those rural idylls which Graham Sutherland and Robin Tanner etched in the mid-1920s might have been made in response to Ford's dreaming at the Front.

The war's other major meaning, however, was social. To Ford the countryside mattered because it was imbued with 'the idea of human companionship' – the idea of conversation and sociability so appreciatively evoked in *No Enemy*. David Jones was more acutely affected by his experiences in Flanders. In the 1920s he moved from refuge to refuge as he searched for security and an image of the whole to set against his memories. The war was the subject of his extended poem of 1937, *In Parenthesis*. His Flanders is imagined as a palimpsest of rumours, snatches of song, commands, glimpses of 'substantial matter guttered and dissolved.' To these memories of 'slime-glisten on the churnings up', his luminous watercolours of a half-dreamed countryside stood as a reproach and as a re-affirmation of the earth's beauty. He too was subject to anxiety regarding impersonality. In the preface to his long poem he looked back affectionately to the companionship he had enjoyed in the early years and recalled how there had been a hardening into a 'more relentless, mechanical affair', with 'a more sinister aspect.' His image for this change, which he judged to have become pervasive by 1937, was of a boatman mending his sail while all around 'the petroleum is hurting the sea.'

10

The boatman absorbed in his work and oblivious to the larger world was also Jones's metaphor for himself and for other artists. Society's problems were simply too large to be coped with or even faced up to. Experiences of the nightmarish war set the tone, and even established a pattern of fearfulness in which sanctuary imagery played an important role.

The war, which had ruined nature and sociability, was worst, but there were other nightmares to be allayed. The first of these was local and long established: in it Britain featured as an industrial wasteland. J. B. Priestley, after travelling the country, conflated premonitions and memories of war in complex metaphorical descriptions of landscape in *English Journey* (London, 1934). This is one account of his response to the Black Country: 'It is on the border of Arden itself. Industry has ravished it; drunken storm troops have passed this way; there are signs of atrocities everywhere; the earth has been left gaping and bleeding; and what were once bright fields have been rummaged and raped into these dreadful patches of waste ground.' Such glimpses of the unthinkable were to be had all over the Midlands and the North. The novelist William Gerhardi writing, in 1939, on 'Climate and Character' for Hugh Kingsmill's *The English Genius* found a nadir in Bolton, then under inspection by the sociologists of Mass Observation: 'Rain fell from an invisible sky. The road stretched before me for ever. Bolton looked like the bottom of a pond with the water drained off . . . here were the people who, if they could endure this, could endure anything.' Artists certainly had no taste for that kind of endurance and, apart from a set of drawings of the Black Country as a quarried landscape by Edward Wadsworth in 1919, this desolated side of Britain was scarcely depicted between the wars. When artists did turn to the industrial landscape in the 1930s their model was the workshop, light, orderly and airy.

The other dark zone, more mysterious than either the war or the ravaged North and Midlands, lay further afield. With its 'heathen' and 'coral strands', this large Elsewhere of more or less dark continents was unsettling and a perpetual threat. It provided a scale against which English homeliness could be, and was, measured and appreciated. In 1936, for instance, Francis Brett Young wrote *Portrait of a Village*, a sequel to the popular *This Little World*, which also had village life as its subject. Joan Hassall did the woodcuts, many of them vignettes in the style of Thomas Bewick. The story opened over mid-Africa where 'puff-adders and cobras lay coiled in their winter sleep.' Five cuckoos, intimidated by a grass fire on the veld, flew north over wildernesses scourged by sandstorms and loud with savage bees. One of their number having been trapped and eaten by a Chinese seaman on the Bay of Biscay, the remainder came home at last to paradise, represented as a village in Worcestershire: 'One dropped to the field called Long Dragon Piece, hard by Goodrest Farm. The second flew straight to the belt of elms which embraces "The Cubbs" at the back of the Sheldon Arms. The third slid swiftly towards a tall lime tree whose shadow fell on the eastern wall of The Grange.'

Agnes Miller-Parker, wood engraving from A. E. Housman, *A Shropshire Lad*, 1940.

And the fourth called out for pure joy. They had arrived in the half-timbered heart of artists' England. Evelyn Waugh had paired these opposites in 1934 in *A Handful of Dust*, set between Hetton Abbey and the heart of the Amazonian jungle. Led astray by a German scientist and explorer and eventually marooned, an English gentleman is left to end his days in alien oblivion; meanwhile at home, 'A light breeze in the dewy orchards; brilliant, cool sunshine over meadows and copses; the elms were all in bud in the avenue; everything was early that year, for it had been a mild winter.' The heartache was authentic in the well-drilled, neon-lit present of the 1930s.

More railed against than war, industry and abroad was modern society. In novels, poetry and polemical essays it was shown as a headed straight down the road to alienation. Edwardian writers had been alarmed by a vision of a technologically determined mankind: Mr Toad, infatuated by motor-cars in Kenneth Grahame's allegorical *The Wind in the Willows* of 1908, embodied this fear. In the 1920s, a decade in which advertising became a major industry, 'vulgarity' became an issue. G. K. Chesterton in an essay of 1927, *Culture and the Coming Peril*, pointed to the degenerative influence of poster art: 'When you walk down the street and see the whole of one side of a great house, so to speak, occupied with an enormous poster on which is written in large letters, "keep that schoolgirl complexion", that exactly fills my definition of vulgarity.' At exactly that time, such artists as Norman Wilkinson, Frank Newbould and F. Gregory Brown were re-interpreting Britain for the transport industry in brilliantly coloured, generalized, weather-free terms. As if in opposition to this bright poster culture, the Nicholsons, David Jones and Christopher Wood chose to work, during the late 1920s, in a primitivist style that was emphatically authentic and in which they honoured the ancient landscapes of Cornwall and Cumberland.

For the literary opposition, led by such distinguished writers as Llewelyn Powys and H. E. Bates, the motor-car was the most readily available symbol of subversion in modern life. With the car came trunk roads, gaudy petrol stations and the 'octopus arms of radial suburbs', as they were described by Vaughan Cornish in *The Preservation of our Scenery* in 1937. The long-term consequences of separation from the land were outlined in 1935 by R. G. Stapledon in *The Land, Now and Tomorrow*. Stapledon, Professor of Agricultural Botany at the University College of Wales and a leading authority on land use, argued thus: 'In any event an environment that is only sophisticated cannot react properly on what is unsopisticated in us, and unless we are nourished all round, we as a species or as a race must either perish ingloriously, or become completely perverted.'

One way of laying hold on reality and of resisting the perils of a sophisticated environment was to walk back along what H. E. Bates called 'the summer road of my childhood.' The culture of trunk and arterial roads, ribbon development, light industry and leisure was a culture of industrious adults playing full roles in a planned society. In

John Buckland Wright,
Landscape with Figure. Pen and ink, c.1928–29.

such public circumstances childhood, with its secrets, was a privileged time and it was to this, knowingly or not, that many artists addressed themselves.

The appeal to childhood took several forms. Some Academy painters, most notably Stanhope A. Forbes, who had been in the forefront of British painting from his days among the Cornish fisherfolk of Newlyn in the 1880s and who was a regular exhibitor into the 1940s, depicted children at play and in conversation in farmyards, villages and on the edge of town. His was an especially intimate version of England, and it was representation from the outside, illustration rather than embodiment. George Henry, born in 1858 and one year younger than Forbes, was as prolific an Academician. He showed a more open countryside with wider skies and sharper tonal contrasts and was equally appreciative of incident and situation: his Britons – adults, rather than children – hike, picnic, play golf and enjoy the view from the bridge. Both artists envisaged a domesticated land in which ordinary life proceeded at walking pace. It was a vision shared, and perhaps pioneered, by such French *intimistes* as Vuillard and Bonnard and practised, in distinctly British terms, by many established painters between the wars; Alfred Munnings, Algernon Talmage and David Murray all favoured a version of Britain as an idyllic land, an ideal site for riding, angling and afternoon tea – a playground for adults.

To restore a palpable sense of the world before the 'fall' into organized and purposeful adulthood, to apprehend things again in their immediacy, meant a more thoroughgoing return to origins. In part it involved a return to an unsophisticated way of painting, as in the work of many of the artists of the 7 & 5 Society in the late 1920s: Ben and Winifred Nicholson, Christopher Wood, Cedric Morris, Frances Hodgkins and David Jones. This entailed a reconstruction of appearances in terms of a childhood aesthetic of toys and modelling. Cedric Morris shaped whatever he painted; his villages and farmsteads in Brittany and Dorset have been manipulated into order, stroked, rolled and kneaded as a child might handle clay or plasticine. Christopher Wood, attentive to stone and ironwork and rigging in Brittany and Cornwall, built in the same deliberate way, and so too did David Jones at Capel-y-ffin in 1926.

Stanley Spencer, who had more of an eye for finish than Morris, Wood and Jones, was a different sort of primitive; he both represented and re-enacted the conditions of childhood. His is an art of close-up in which objects stand out emphatically, and it looks like the vision of a child for whom the world lies within arm's length, as close to touch as it is to sight. He indicated as much in the many images of children who inhabit his foregrounds, clutching grasses and flowers and gazing in the shadows of the main event. His stated intention, from a memoir set down in the 1950s, was to assuage a longing to be associated with nature. The subject of the memoir was a painting of 1939, *Christ in the Wilderness: Consider the Lilies*, in which Christ is pictured on all fours, eyes to the flowered earth, in a pose remembered from his daughter's infancy.

Norman Hepple, illustration from Mary Webb, *The Golden Arrow*, 1930.

John Nash, *September*.
Illustration from John Pudney,
Almanack of Hope, 1944.

Access to a child's vision may have been available to Spencer with his powerful longings, but for most people childhood was anything but a time of immediacy. Children's literature, rich in allegory, idyll and social observation, was no more naive than the grown-up version. Furthermore, childhood was as subject to modernization as any other branch of life. Meccano and plasticine made the inter-war youngster into a young constructor, likely in later life to construe landscape as 'toy scenery', as the poet Edwin Muir described Sir Walter Scott's Eildon Hills in *Scottish Journey* (London, 1935).

In short, modern influences were insistent. They were also under suspicion, if not actually in ill-repute. In Britain modernism as a style was associated with leisure. In the 1920s and 1930s it meant sylishness, fashion, week-ends. Britain's most exuberant exponents of modern idioms were such illustrators as McKnight Kauffer and John Armstrong, whose country places are peopled with sprightly visitors. Otherwise modernism was a joke; like adolescence, it was something one grew out of. A. P. Herbert disposed most thoroughly of the modern impulse in 1930 in *The Water Gypsies* where an old Etonian painter of 'parallelograms, equilateral triangles, wood-blocks, stove pipes, and bowler hats' is saved from absurdity by a meeting with a bargee's daughter, a representative of common sense and the natural world, belonging to a class of free, nomadic people into the bargain.

Nevertheless artists did try to negotiate nature and design, the organic and the inorganic. Paul Nash tried most persistently. His paintings of the sea, mainly from Dymchurch in the early 1920s, show the waves in steady sets, and in the mid 1930s he matched geometrical solids with comparable shapes in nature. But Nash tended to assemble rather than to synthesize: antithetical elements, such as a tennis ball and the bruised root of a tree, merely co-exist on the same site, in opposition.

Nash and Nicholson tried to mediate between extremes, and to keep those extremes in being. They were exceptions. Most landscape artists preferred to naturalize the modern or to infiltrate it into traditional subjects. One of the most respected of these subjects was the White Horse at Westbury, understood to have been cut in honour of King Alfred's victory over the Danes. It was used by ramblers in 1937 as a symbol in their fight against reactionary landowners and the trespass laws. In 1940 the same animal appeared in miniature, almost like a lapel badge, in one of the windows of Eric Ravilious's up-to-date *Train Landscape*; in that context it invested the present day with ancient virtue, much as Eric Fraser's lively Mr Therm brought sparkle to the products of the Gas, Light and Coke Company. Ravilious with his quick, graphic style modernized ancient landscapes to the point where they look as designed as modernist fabrics.

Ravilious invested nature with the functional look of modern design. In an alternative approach to the problem of the modern, artists became surveyors of a sort

and represented the countryside panoramically. James McIntosh Patrick, a major exponent of panoramic landscape, mapped the farmlands of Angus. Looking down on Eskdale, he saw a land fenced, walled and compartmented. Here and there the pattern of fields is broken by tidy steadings and stackyards. Hinds and ploughmen, herdsmen, farmers and 'keepers work and watch in the fields. The artist presumes an attentive audience with an eye for south-facing beehives and other fine points of country life, but his principal subject is land utilization. Thus the idea of system is lodged in a native habitat and given a local form.

Survey art was, of necessity, lucid and panoramic, for it was an informative art, intended to make things plain. In the Second World War this tendency was accentuated: Richard Eurich, for example, painted encyclopaedic surveys of the Battle of Britain and of the withdrawal from Dunkirk. Artists in camps, ports, barracks, factories, hospitals and schools worked for an audience which wanted information on just what a convoy looked like, or what was meant by a searchlight battery, or a war industry, or a control room.

In response to this lucid, informative public art there developed an aesthetic of loneliness. The pattern was already established in the 1930s, particularly in the work of Eric Ravilious, who represented the practical world in watercolour and in plain daylight and kept mountains, forests and other Sublime subjects for the strongly contrasted blacks and whites of his wood engraving. Ravilious had a public and a private style, and the private style he mostly reserved for book illustration – for books implied seclusion and reverie, as opposed to the public circumstances associated with painting.

Working in two opposing styles, Ravilious was in a minority. To some extent John Piper, too, dealt with contemporary antitheses when he applied an analytical rhetoric of cross sections and contours to the tumbled chaos of wild landscape. But as a rule those artists who were preoccupied with privacy and loneliness scarcely even acknowledged the tidy linearity of modernist aesthetics. Victor Pasmore, who had painted scenes from street life in the 1930s, in the war years became a landscapist devoted to quietude. Graham Sutherland who had begun by picturing sanctuaries in a pastoral countryside turned more and more as the 1930s unfolded to the wilder reaches of Britain: his landscapes of the 1940s with their abraded forms, spectacular lighting and often lurid colouring look more bracing than welcoming. In a letter Sutherland expressed his feelings for the landscape of Pembrokeshire, to which he was so attached. From 1936 onwards 'such country did not seem to make men appear little as does some country of the grander sort. I felt just as much part of the earth as my features were part of me.' For him, Pembrokeshire established a human measure by means of which a sense of self might be sustained. Most other Neo-Romantic sites, in Wales, Cornwall and Devon, were on a similar human scale. Rocks, sunken lands and deep woods

Lynton Lamb, *The Viaduct*. Woodcut from Lynton Lamb, *County Town*, 1950.

Eric Ravilious, wood engraving from Martin Armstrong, *Fifty-four Conceits*, 1933.

provided cover and brought the stuff of nature close to hand. Sublime landscape in which men 'appear little' was avoided: neither Scotland nor the Lake District attracted the Neo-Romantics.

Despite Sutherland's feelings of oneness with the earth there are disquieting qualities in his art, as in much of the landscape art of his contemporaries in the late 1930s and in the 1940s. Their crags and thorns and tangled woods have few homely qualities. A writer or poet home from a war might find refuge in such places, but no one would go to them for sanctuary or ease. They lie a long way from the blissful cottage landscapes characteristic of the 1920s.

The term Neo-Romantic was only applied to this phase in landscape art towards the end of the 1940s. It was a term probably coined by the critic and painter Robin Ironside, but used by him tentatively. The landscape artists of whom he wrote, John Piper and Graham Sutherland, were evidently Romantics, but they were something more besides. As he assessed Sutherland's art, Ironside intensified his tone, became a prophet speaking from the wilderness: 'his mountains burning at sundown are the theatre of human passions and his woods are the womb of human impulses; and the grotesque bifurcation of the dead or dying tree-trunk which, in the first phase of his maturity, was the symbol of his predilection, seems to lay a disturbing stress on the insecurity of a faithless generation.'

The Neo-Romantics were seers, prophesying and recalling ancient truths in a secular age. But they often spoke despairingly, as though only memories survived. In an introduction to *The Poet's Eye* in 1944 Geoffrey Grigson, one of the most powerful voices of the period, referred to origins almost beyond recall: 'The way in which, in its rhythmical place, a bare word like "hill" or "tree" or "green" may stir you with its emotion, probably derives from an earlier clear-sightedness.' In the 1950s he wrote as though those origins were truly beyond recall. In *Freedom of the Parish* (1954) an evocation of a childhood in Cornwall spent close to the land, he implied a turning point long past: 'I read commentators on the poems of Gerard Manley Hopkins who cannot know an object, from chervil to a windhover, which he uses for the vehicle and substance of his meaning, I read urban historians who reduce art to a scholarship of style because they have no experience of night or light or natural shapes and have had no existence outside the art gallery or the print room or on the streets.' Thus the curtain was brought down on a long Age of Landscape, opened by Constable and ended as a last-ditch affair among the rocks of Pembrokeshire.

Opposite. 1 Allan Gwynne-Jones, *Spring Evening, Froxfield*. Etching, 1926.

I
DREAMING:
visions of a radiant countryside

Entrenched in Flanders, British artists dreamed of a respite and a
return to an ideal remembered landscape of 'tiny, dear places'.
Conditions changed, and memories of the Great War faded, but the
dream continued. The ideal place was on an intimate, human scale,
sociable rather than solitary. Artists toured its villages and valleys on
foot, and glimpsed its gardens from their windows. It was an imagined
or a remembered place, and thus often had the look of
a stage set or a model.

2 David Jones, *Brockley Gardens*. Pencil and watercolour, 1926.

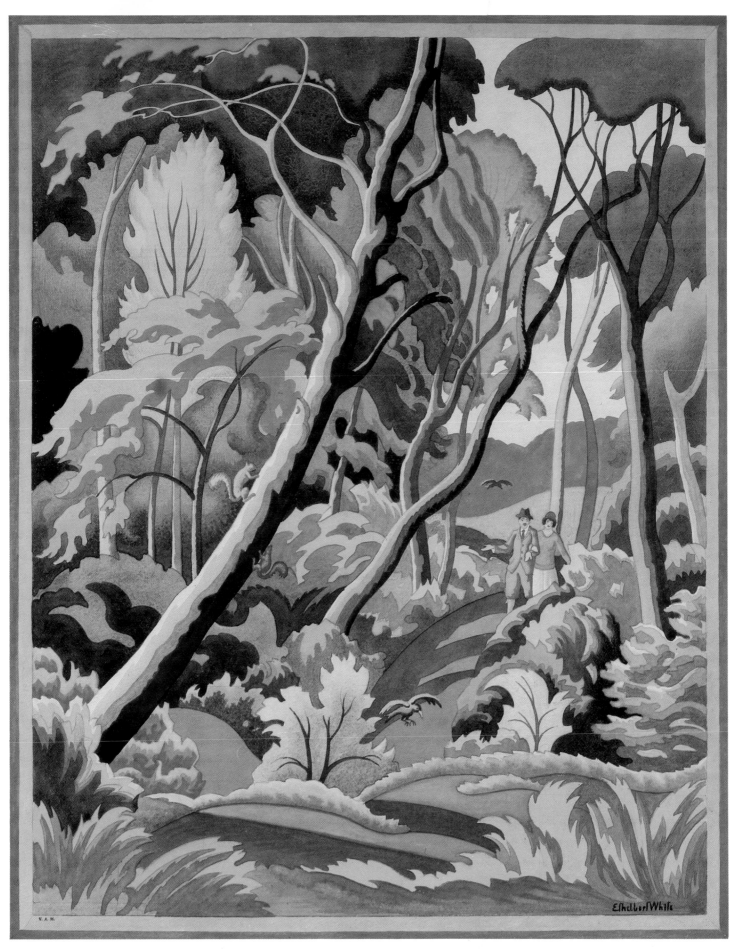

3 Ethelbert White, *Summer*. Design for a poster. Tempera, c.1925.

Summer sounds

Nature confided in whispers and asides, in the murmur of insects in foliage, the hiss of water in a sluice, and the rustlings of birds.

4 Graham Sutherland, *The Sluice Gate*.
Etching, 1924.

5 William Larkins, *Troutwater*. Etching, 1926.

6 Gertrude Hermes, *Willows and Waterlilies*.
Wood engraving, 1930.

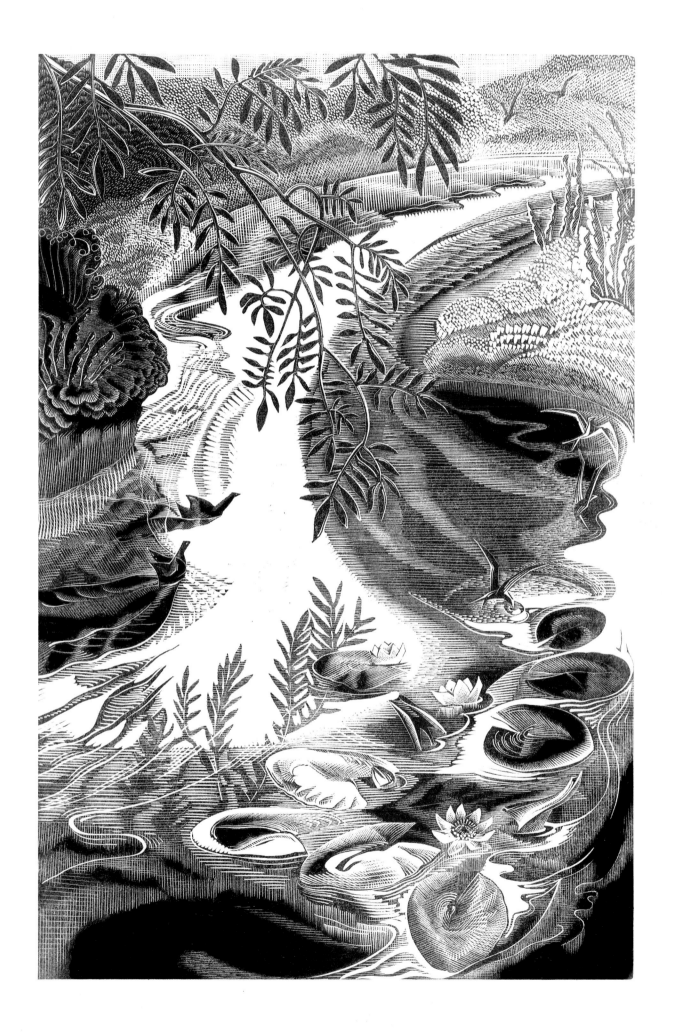

Resting places

Country roads brought travelling artists to
the peaceable seclusion of long-established homesteads
in almost forgotten valleys.

7 Cedric Morris, *South Pembrokeshire Landscape*.
Oil on canvas, 1934.

8 Charles Rennie Mackintosh, *The Downs, Worth
Matravers*. Watercolour, 1920.

9 Paul Nash, *Souldern Pond*. Oil on canvas,
c.1923–24.

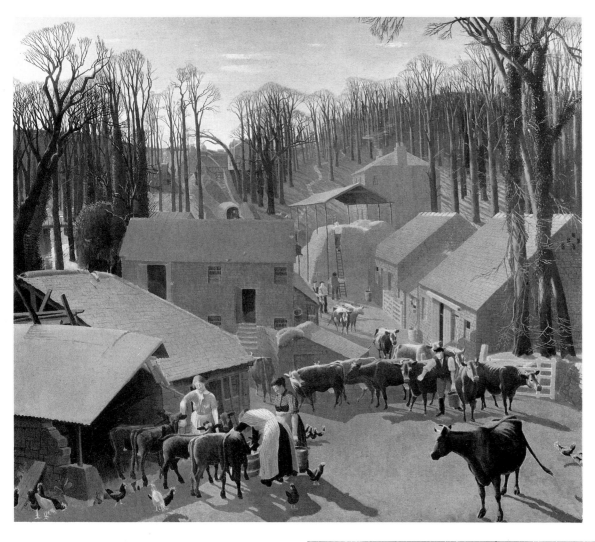

Country havens

The churchyard of St Giles at Stoke Poges
had been the site of Thomas Gray's wistful looking
back. Later idylls featured a more workaday
countryside of lanes and farmyards.

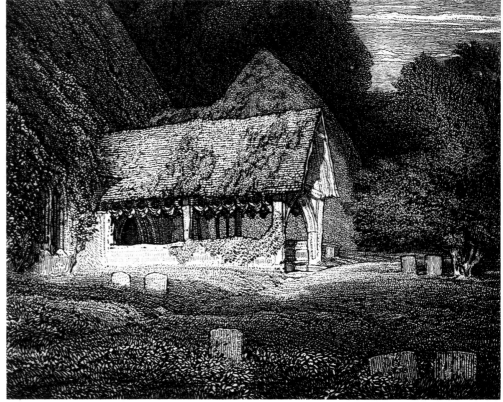

10 Allan Gwynne-Jones, *Poltesco Farm, Ruan Minor,
Cornwall*. Oil on panel, 1920–21.

11 F. L. Griggs, *The Porch of the Church of St Giles,
Stoke Poges*. Etching, 1918.

12 Graham Sutherland, *Cottage in Dorset*.
Etching, 1929.

13 Gwenda Morgan, *The Walnut Tree*. Wood
engraving, *c*.1935.

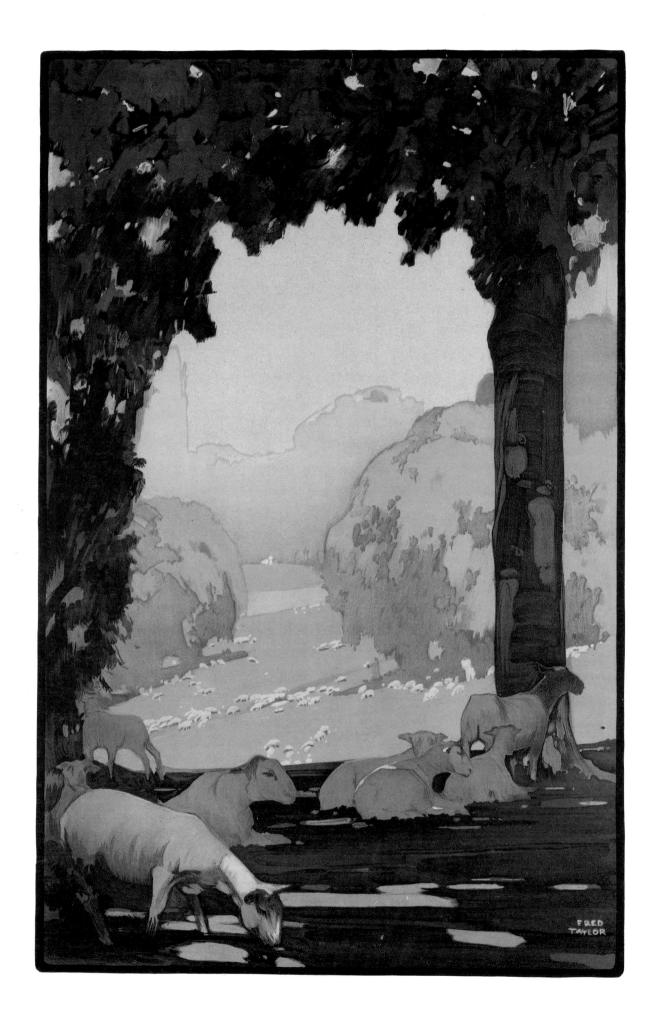

14 Fred Taylor, *Hampstead, London Memories*. Poster, 1918.

15 Paul Nash, *The Thatched Cottage*. Oil on canvas, 1926.

Fragments from nature

Artists acknowledged what they could not
represent: summer's fragrance might be suggested
in a vase of flowers, and winter in stripped
branches. Thus nature was brought indoors, onto
a domestic scale.

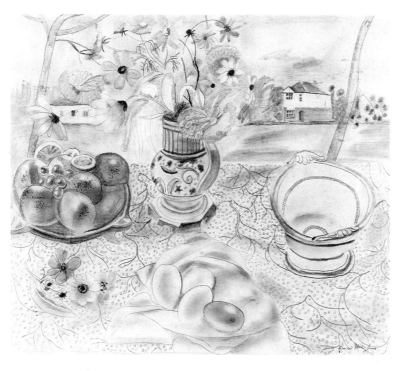

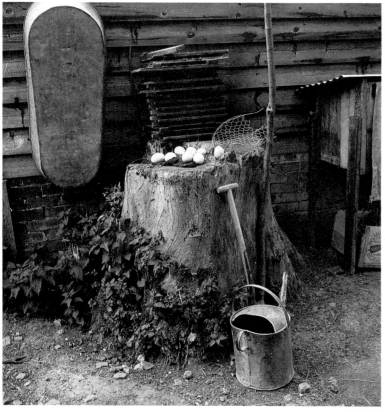

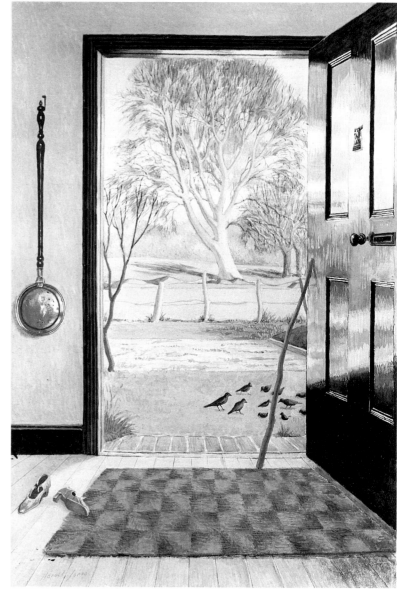

16 Frances Hodgkins, *Still-life*. Pencil drawing, *c.*1929.

17 Cecil Beaton, *Country Still-life with Eggs*. Gelatin silver
print, *c.*1940–49.

18 Harold Jones, *The Black Door*. Gouache, *c.*1935.

19 Duncan Grant, *The Doorway*. Oil on canvas, 1929.

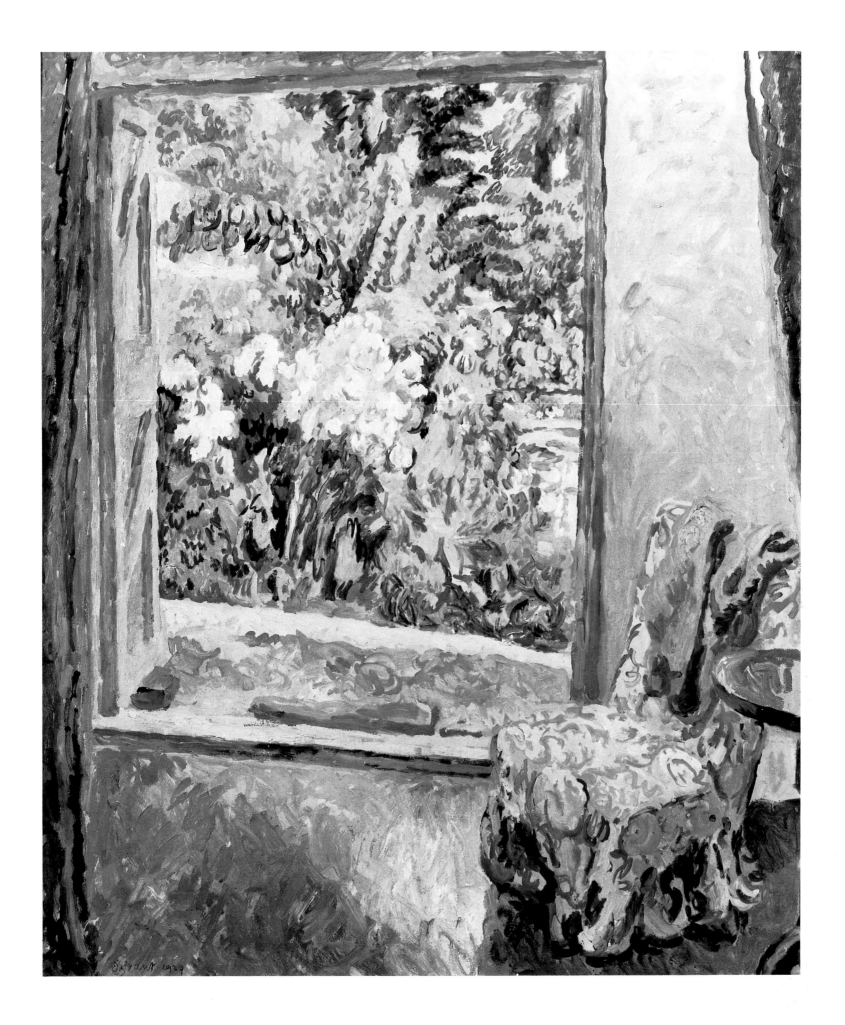

Design and the countryside

In the more vigorous of these country idylls,
opposites are composed, reconciled: shadow and sunlight,
hillside and valley, woodland and water. The landscape
is imagined as an assemblage pieced
together with vivid elements.

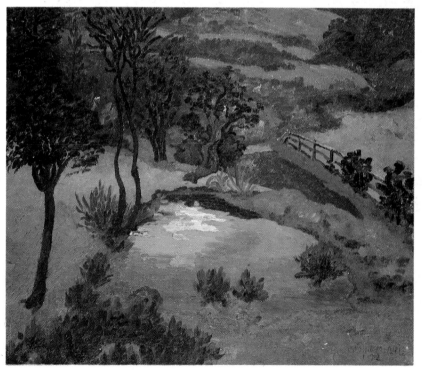

20 F. Gregory Brown, *Dorking*. Design for a poster. Gouache, 1920.

21 Brian Cook, design for the dust jacket of C. B. Ford, *The Landscape of England*, 1933. Gouache on board.

22 Cedric Morris, *The Red Pond*. Oil on canvas, 1933.

Portable scenery

Artificers' landscape, with its building blocks and simplified,
portable scenery, had Cubist origins and grew out of the aesthetic
of lucidity and order which shaped modern design in the 1920s.

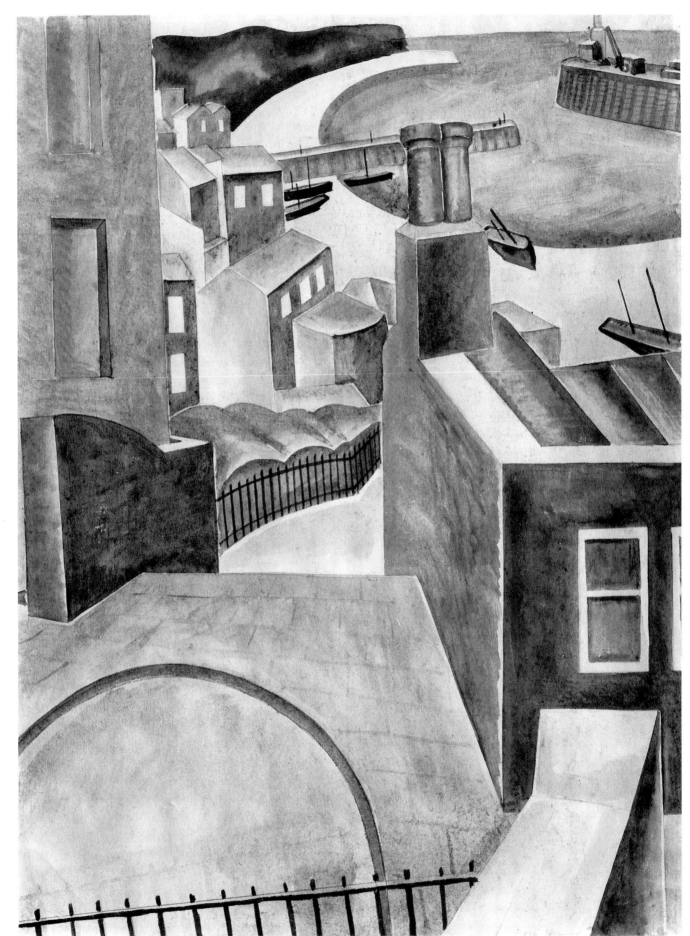

23 Edward
Wadsworth, *Roofs
and Bridges*. Pencil
drawing, 1921.

24 Percy Horton,
Kensington Gardens.
Pencil drawing, 1923.

25 David Jones, *The
Garden Enclosed*. Oil
on canvas, 1924.

26 Jessica Dismorr,
Folkestone Harbour.
Pencil and water-
colour, 1924.

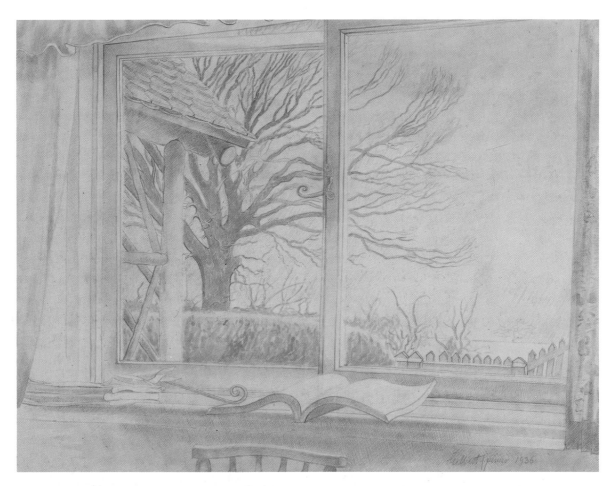

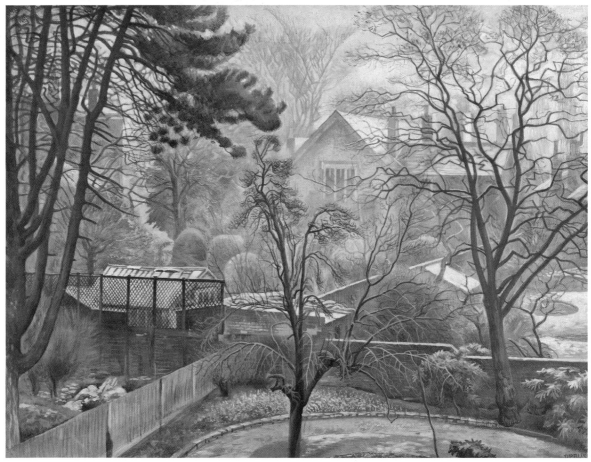

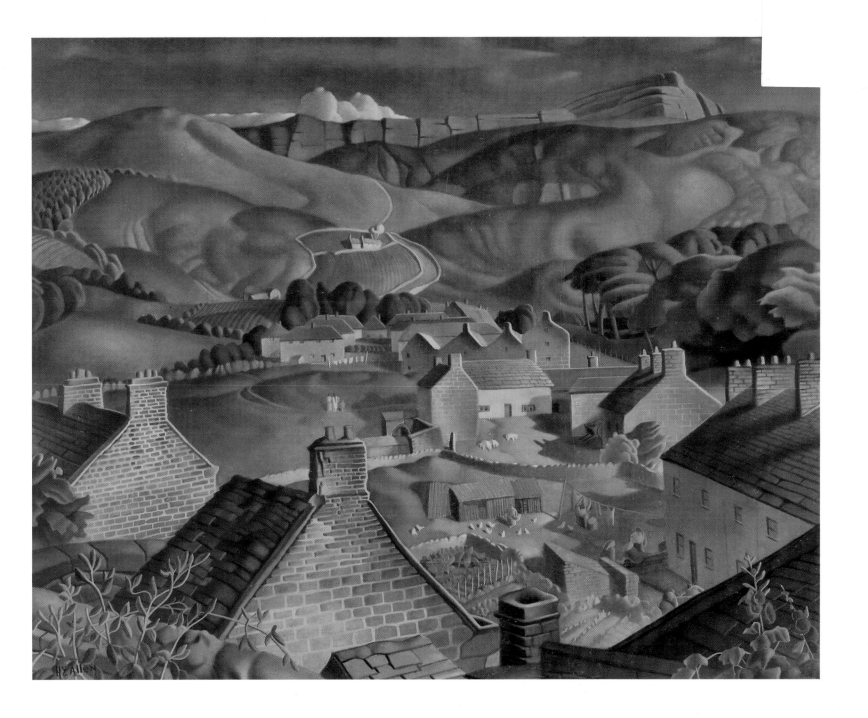

Setting limits

Held at a distance and framed by window or terrace,
nature can be managed, and its profusion controlled. The landscape
may even become a set of inscriptions to be read,
like the characters on a printed page.

27 Gilbert Spencer, *Winter Landscape*.
Watercolour, 1936.

28 D. P. Bliss, *February in My Garden*.
Oil on canvas, 1938.

29 H. E. Allen, *Hathersage, Derbyshire*.
Gouache on board, *c*.1949.

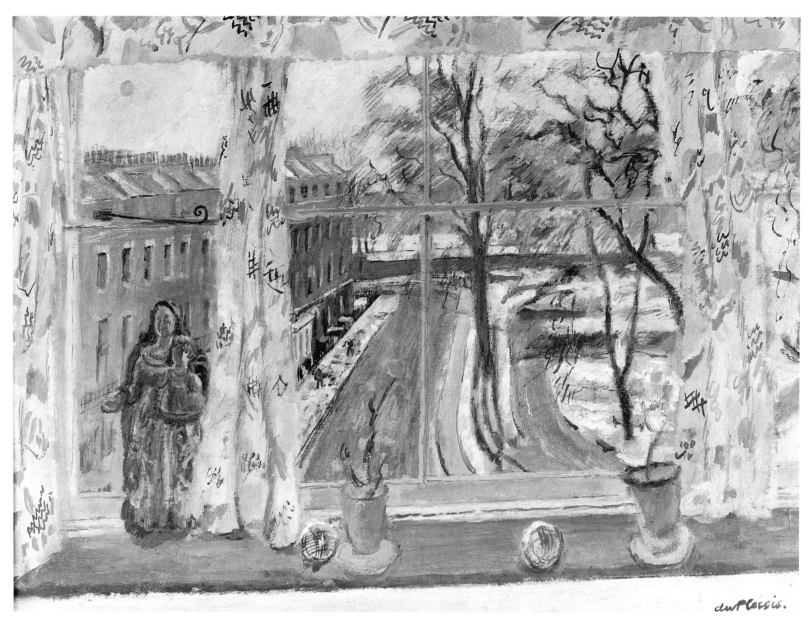

The outside inside

Seen across the threshold of a door,
window or terrace, the outside world often
appeared to be no more substantial than
a decorative supplement to a room, a
background to ornaments on a sill
or flowers in a vase.

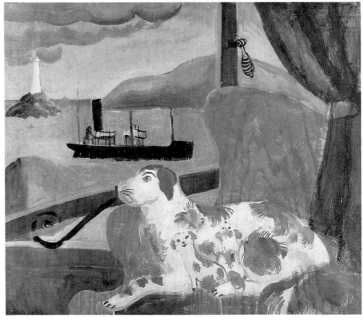

30 H. E. Du Plessis, *Mecklenburgh Square*. Oil on canvas, 1947.

31 Ivon Hitchens, *Winter Stage*. Oil on canvas, 1936.

32 David Jones, *The Chapel in the Park*. Watercolour, 1932.

33 Christopher Wood, *China Dogs in a St Ives Window*. Oil on board, 1926.

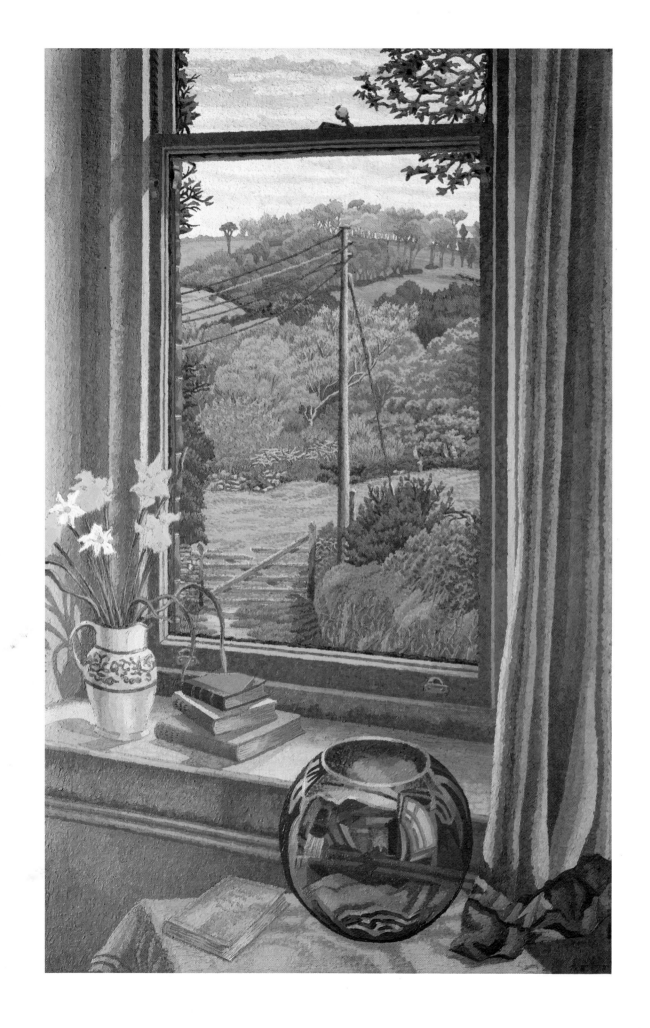

Landscape as fabric

In pictures so
elaborately compiled as these,
artists found a process imitative of
the painstaking habits
of manual labour.

34 Charles Ginner, *The Window*.
Oil on canvas, 1943.

35 Claughton Pellew-Harvey, *Embankment at Night*. Ink, pastel, gouache and watercolour, 1920.

36 Charles Ginner, *Back Garden, Frimpton-on-Sea*. Ink and watercolour, 1947.

37 John Minton, *Cornish Village*. Ink and gouache on paper, 1945.

38 Alfred Wallis, *St Ives*. Oil, pencil and crayon on card, *c.*1928.

39 Alison McKenzie, *The Cod and Lobster Inn, Staithes*. Wood engraving, 1938.

40 Joseph Southall, *A Cornish Haven*. Watercolour, 1930.

41 F. C. Jones, *Chimney Stacks and Winding Ways, Whitby*. Pencil drawing, 1936.

Habitable places

Nestling villages, compact farmsteads
and functional quaysides provided material from
which artists shaped their miniature landscapes
or images of containment.

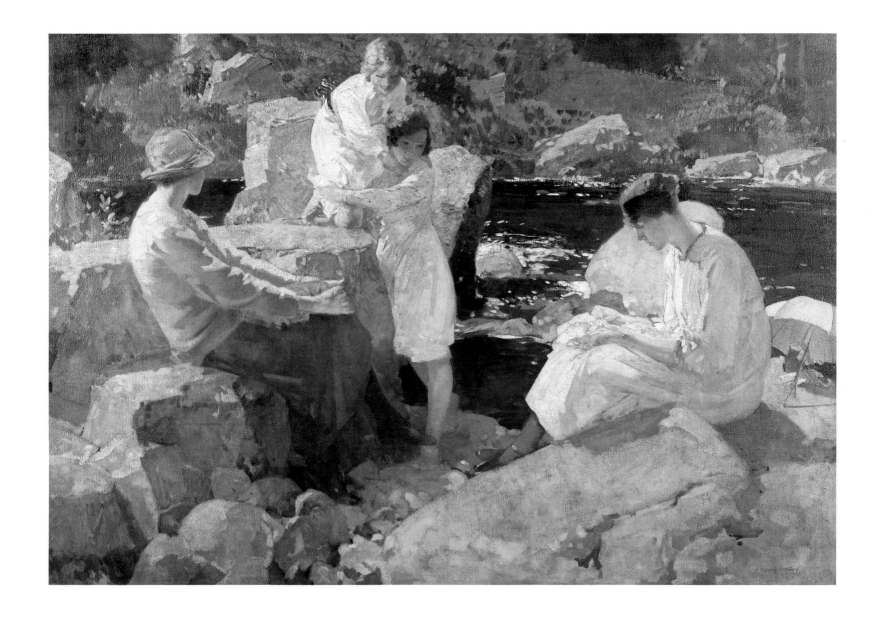

Nature's playground

In tourism a safe distance
must be maintained if mountains and crags
are to be kept as scenery – hence these various
evocations of tranquillity in the
midst of wilderness.

42 Harry Watson, *Holidays*. Oil on canvas,
c.1922.

43 Leonard Squirrell, *A Dovedale Gorge*.
Watercolour, 1922.

44 Norman Wilkinson, *The Trossachs*.
Poster, c.1925–30.

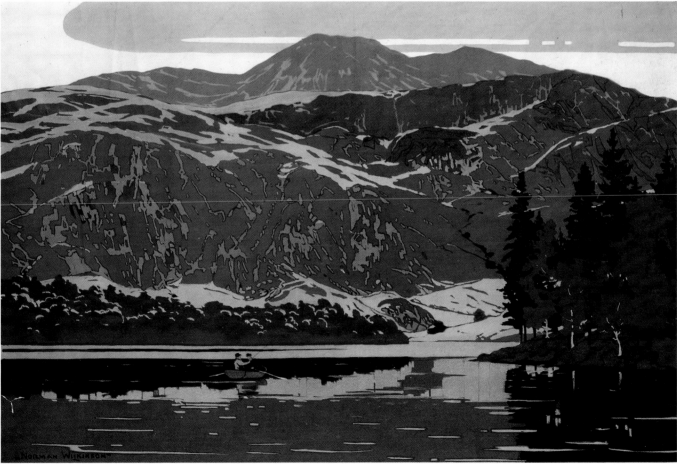

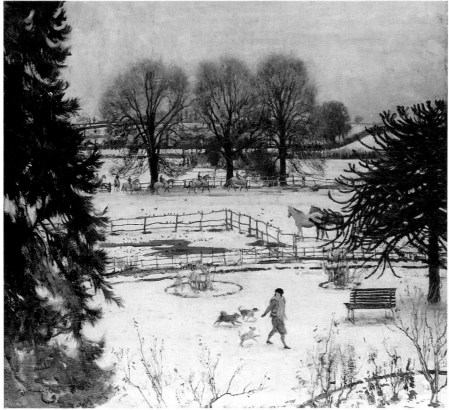

45 James McIntosh Patrick, *Winter in Angus*. Oil on canvas, 1935.

46 Alfred Munnings, *From My Bedroom Window*. Oil on canvas, 1930.

47 D. P. Bliss, *Crofts in the Quirang, Isle of Skye*. Watercolour, 1921.

48 Kenneth Rowntree, *The White House, Torcross*. Oil on canvas, 1938.

49 Ellis Martin, illustration for the Ordnance Survey map of Land's End and the Lizard, 1919.

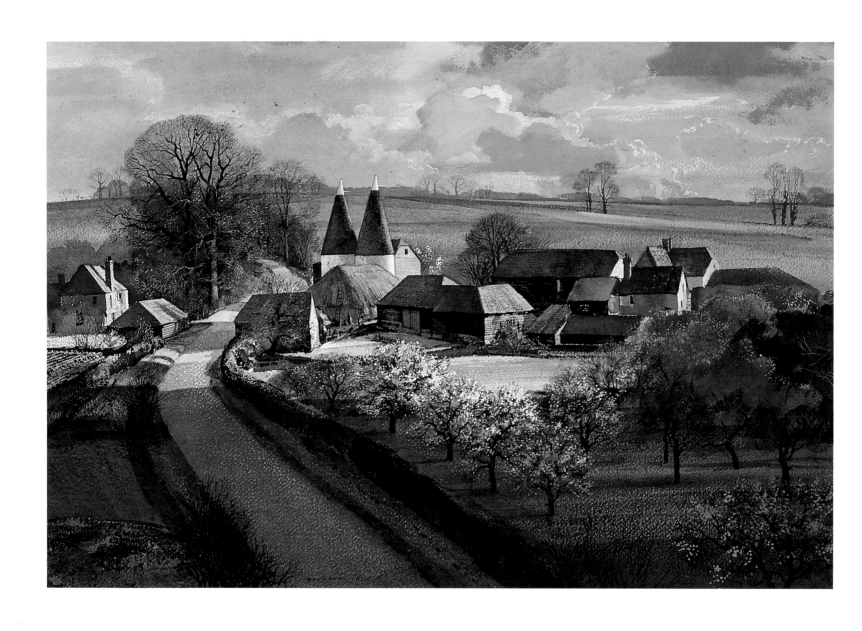

Slow time

In such fluent, continuous spaces as these,
artists suggested an alternative to the broken, fretful time
of ordinary days. To be assimilated into such graceful vales
and moorlands was to be at home in nature.

50 Rowland Hilder, *The Garden of England*. Watercolour and pencil, 1945–50.

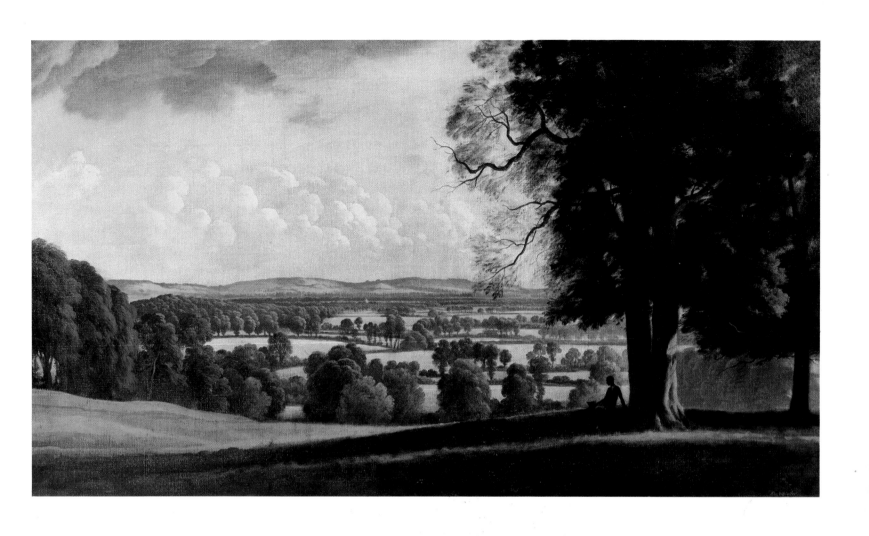

51 Rex Whistler, *The Vale of Aylesbury*. Oil on canvas, 1933.

52 Gwen Raverat, woodcut from Frances Cornford, *Mountains and Molehills*, 1934.

53 Duncan Grant, *The Farm Pond near Firle, Sussex*. Oil on canvas, 1930–32.

54 Stanley Royle, *Morning on the Derbyshire Moors*. Oil on canvas, 1920.

SPRING

ON THE HILLSIDE

E MCKNIGHT
KAUFFER

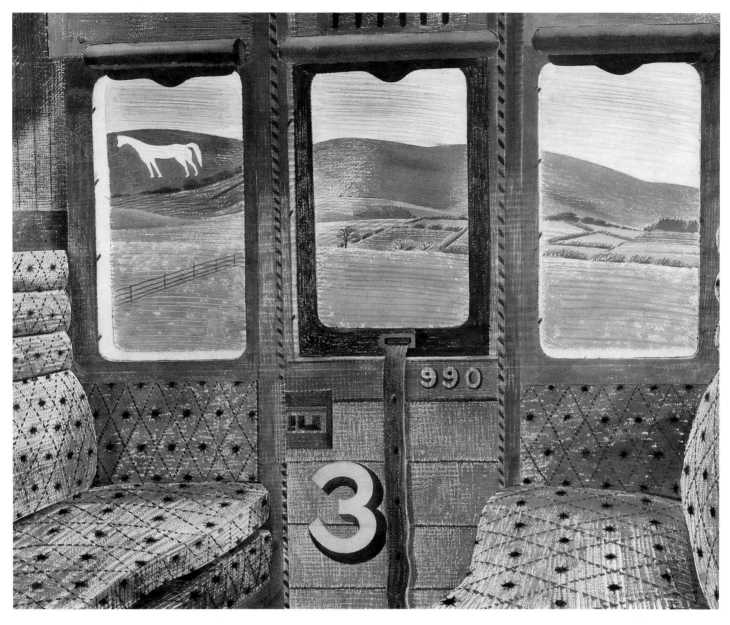

Country collage

In a culture of mass communication where significant details mattered, the seasons might be summed up in a word and a photograph, and the past expressed in a handful of relics.

55 McKnight Kauffer, *Spring on the Hillside*. Poster, 1936.

56 Eric Ravilious, *Train Landscape*. Watercolour, 1940.

57 Clifford and Rosemary Ellis, *Antiquaries Prefer Shell*. Gouache on paper, 1934.

58 Cedric Morris, *Stoke-by-Nayland*. Oil on canvas, 1940.

59 Charles Mahoney, study for *Adam and Eve in the Garden of Eden*. Watercolour and pencil, c.1936.

60 Joan Hyde, *Cobbett's Rural Rides*. Woodcut, 1937.

2
THE WORKING LANDSCAPE:
farms and quarries

During the 1930s Britain was electrified, analysed and
modernized. Documentary was the mode of the decade. Surveying
became a model for painting, and details of the working
countryside were to be read in the panoramic landscapes of
Stanley Spencer and James McIntosh Patrick. Otherwise the land
was shown refined and brought to diagrammatic clarity in the
lucid, barebones illustrations of Eric Ravilious and Barnett
Freedman. It was an age of functional landscape, of tidy farms
and sharp-edged quarries. The lucid style survived into the 1940s
when it was countered by a return to the ruggedness of
Pembrokeshire and Cornwall.

Introductory plate.
61 Barnett Freedman, *Caves Farm*.
Ink drawing, 1933.

62 John Nash, lithograph from Adrian Bell,
Men and the Fields, 1939.

63 James McIntosh Patrick, *Autumn, Kinnordy*.
Oil on canvas, 1936.

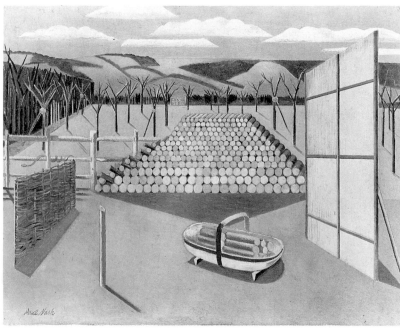

64 William Townsend, *The Hop Garden*.
Oil on canvas, 1950.

65 Paul Nash, *Landscape at Iden*. Oil on
canvas, 1928.

The lucid style

Kent was the most popular working
landscape in Britain among artists of the 1930s.
The very look of the countryside, with the ostentatious
functionalism of its oast houses, orderly hop
gardens and tidily pruned orchards, was
that of an artefact in the geometrical
modern style.

66 H. S. Williamson, *September Hop-picking*.
Lithograph, 1943.

67 Percy Horton, *Barn and Oast Houses at
Marden, Kent*. Watercolour, 1930.

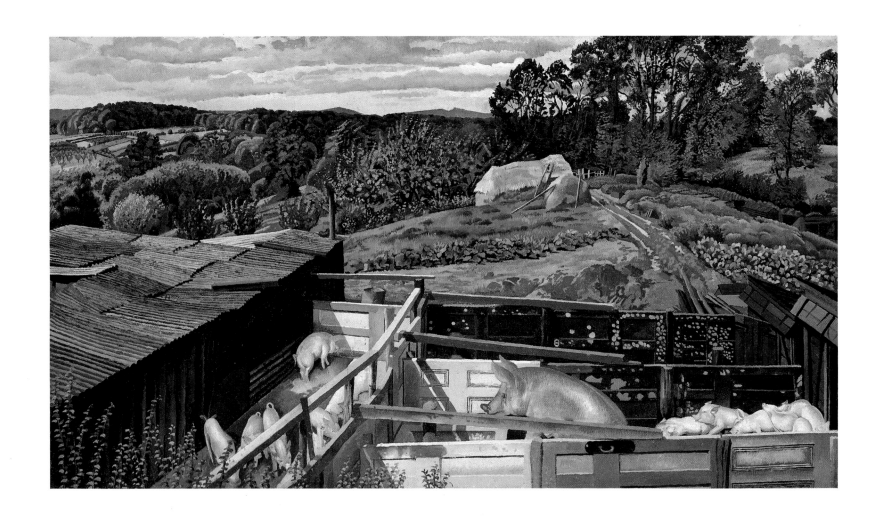

Rural idioms

The sound of Bateman's scythes
harmonizes with a mellow countryside.
Spencer's farm place, with its rowdy pigs and patchwork
of ragged tin and broken doors, is expressed
in an agitated modern style.

68 Stanley Spencer, *Rickett's Farm, Cookham Dean*. Oil on canvas, 1938.

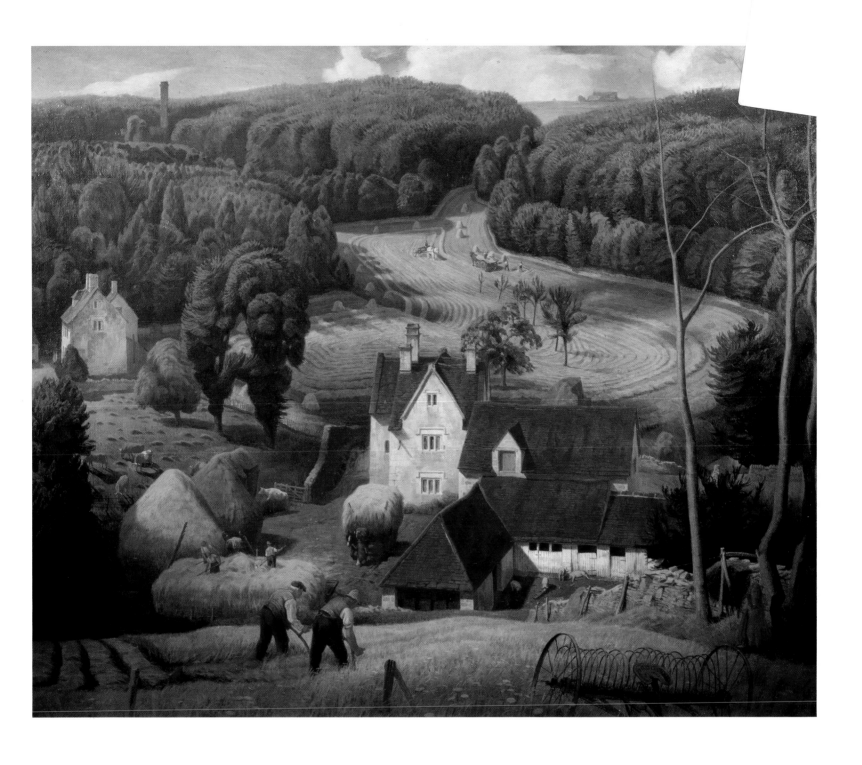

69 James Bateman, *Haytime in the Cotswolds*. Oil on canvas, 1939.

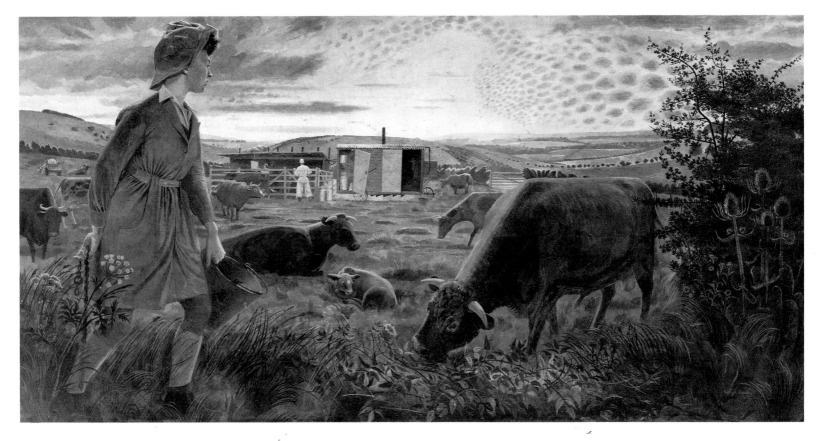

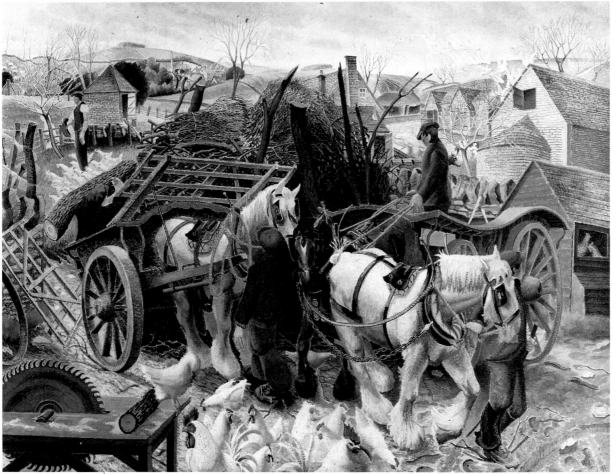

70 Evelyn Dunbar, *A Land Girl and the Bail Bull*. Oil on canvas, 1945.

71 Gilbert Spencer, *A Cotswold Farm*. Oil on canvas, 1930–31.

72 James Bateman, *Pastoral*. Oil on canvas, 1928.

73 Clare Leighton, *February*. Illustration from Clare Leighton, *The Farmer's Year*, 1933.

74 R. Coxon, *October Tree-felling*. Lithographic poster, 1945.

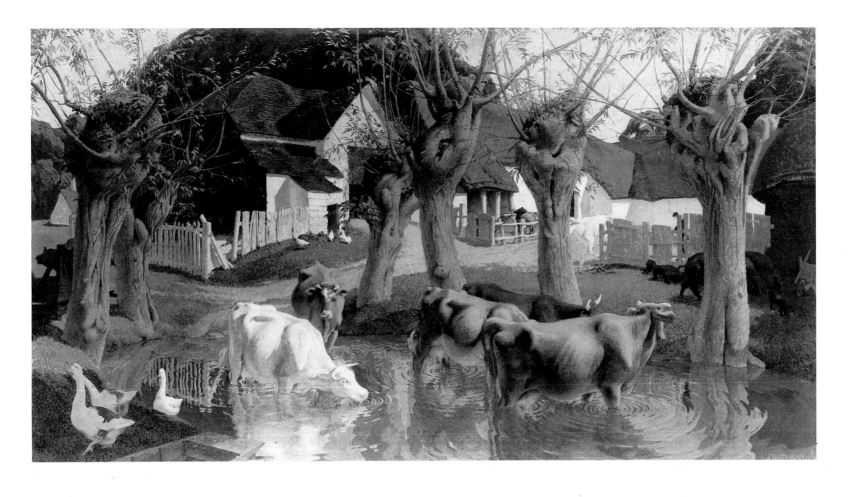

Heroic labour

Just as rural life was envisaged in ideal terms,
so rural labour was heroized, for it embodied the spirit
of the people – a spirit in danger of diminution by
experience of mass society.

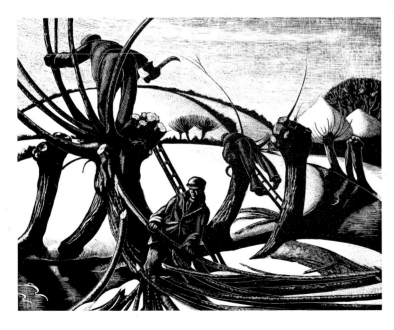

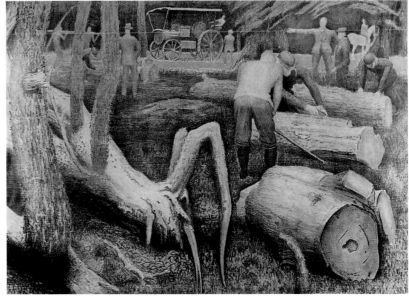

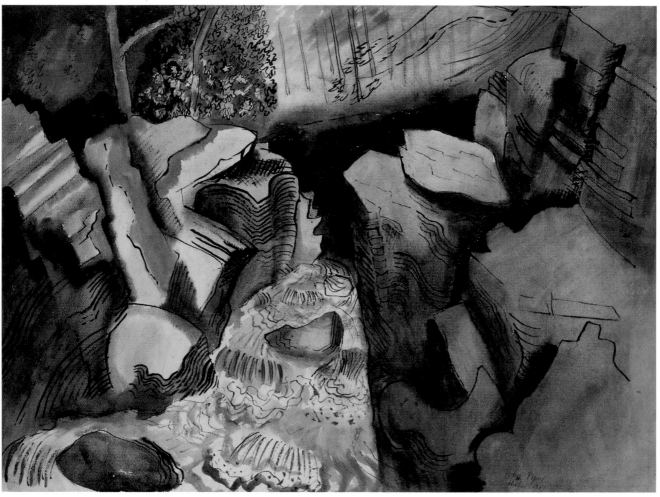

Human imprints

Artists cherished such signs as the neat incisions made by quarrymen. Even the wilderness here seems gauged, contoured and cross-sectioned – and infused with the modern spirit.

75 John Piper, *Portland, the Top of the Quarry*. Ink and water-colour, *c*.1940.

76 John Piper, *Up the Gorge, Hafod, North Wales*. Watercolour, 1939.

77 McKnight Kauffer, *Flowers of the Hills*. Poster, 1930.

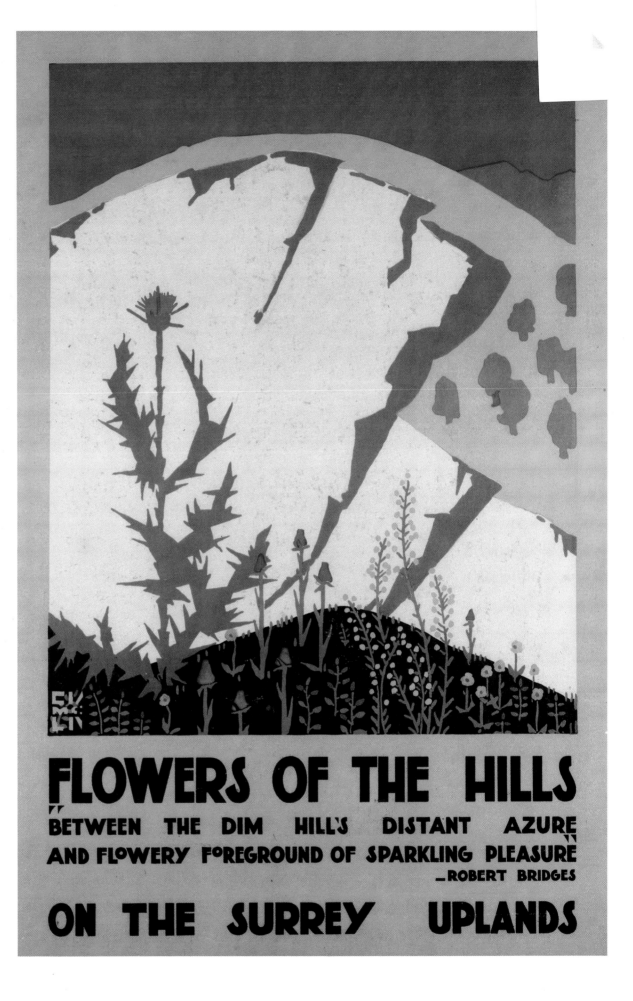

FLOWERS OF THE HILLS

BETWEEN THE DIM HILL'S DISTANT AZURE AND FLOWERY FOREGROUND OF SPARKLING PLEASURE
—ROBERT BRIDGES

ON THE SURREY UPLANDS

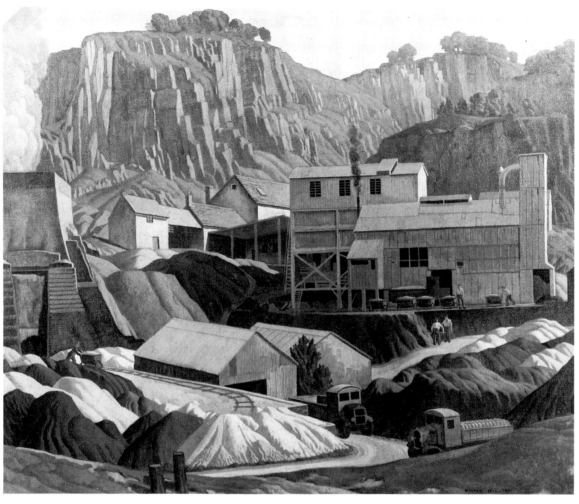

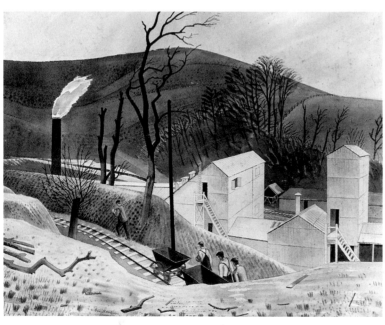

78 Walter Bell, *Derbyshire Quarry*. Oil on canvas, 1937.

79 Eric Ravilious, *Cement Works, No. 2*. Watercolour and pencil, 1935.

80 Duncan Grant, *Lewes Landscape*. Oil on paper laid on board, 1934.

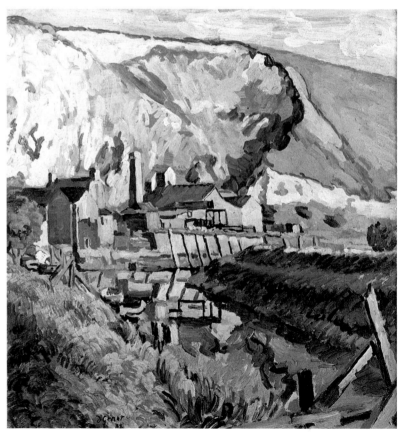

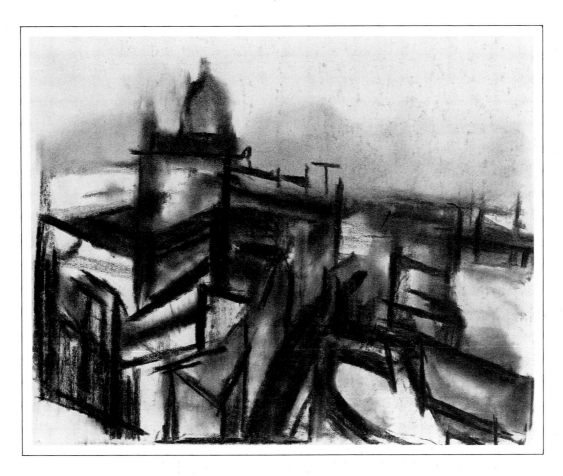

3
EPIC SCENERY:
through chaos to harmony

Such artists as David Bomberg and Bernard Meninsky, who were
indifferent to the small-scale comforts of the British countryside,
sometimes found grandeur in themselves, in an internal pulse and
rhythm which enabled them to show the world enhanced. Others who
wanted to acknowledge the greater order underlying nature, the order
which was so disrupted by war and industry, turned to the wild places
of Britain, to unspoiled moorlands and estuaries. Yet these latter artists
always worked to a human scale, preferring hills to mountains, woods
to forests. Nor was their nature truly wild; it often bore traces of
prehistoric workings in earth and stone, and was governed by the
movements of the sun and moon, and patterned by the
regular order of the tides.

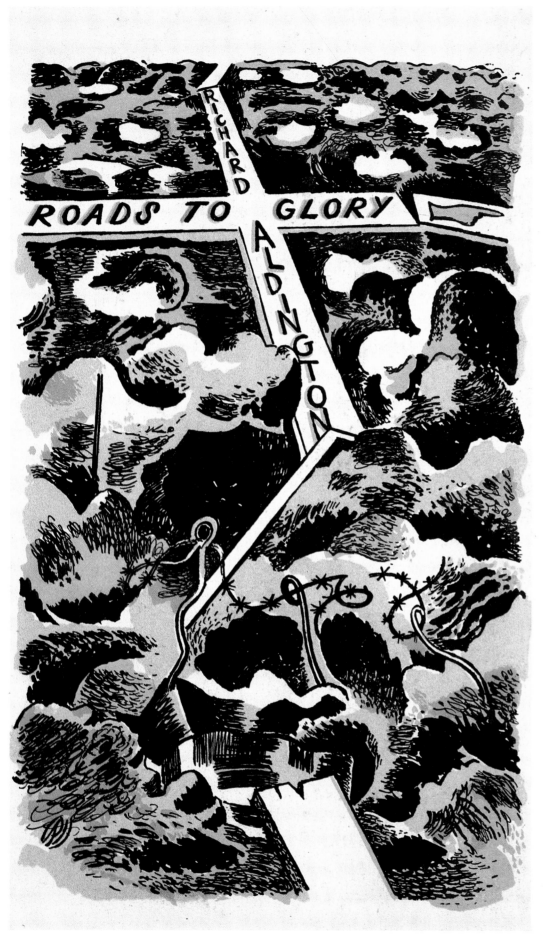

Introductory plate.
81 David Bomberg, *St Paul's and River*.
Charcoal on hand-made paper, 1945.

82 Paul Nash, design for the dust jacket
of Richard Aldington, *Roads to Glory*,
1930. Coloured inks.

83 L. S. Lowry, *Lake Landscape*.
Oil on canvas, 1950.

84 John Tunnard, *Morrah*.
Black chalk, watercolour and
gouache, 1955.

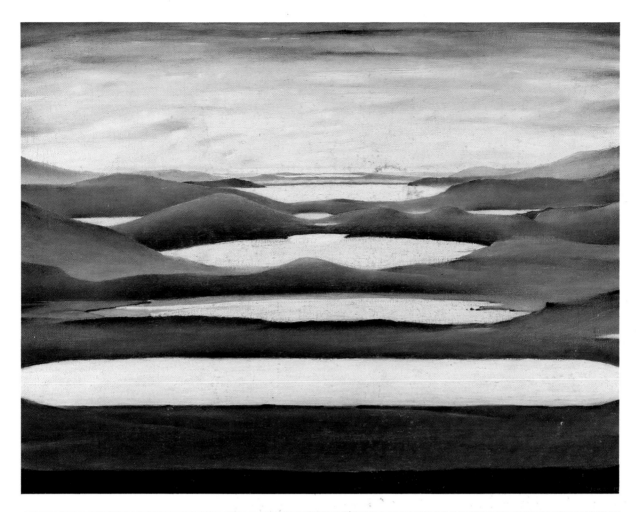

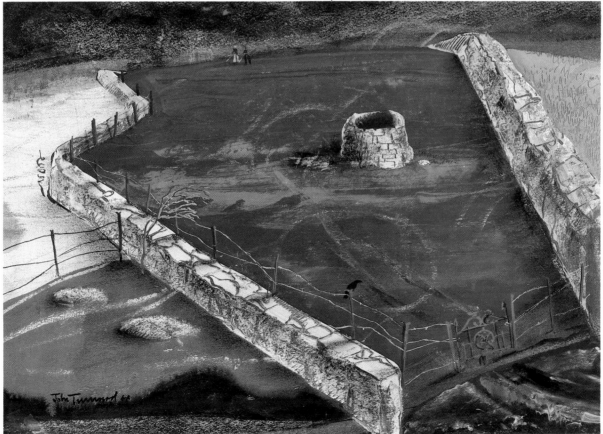

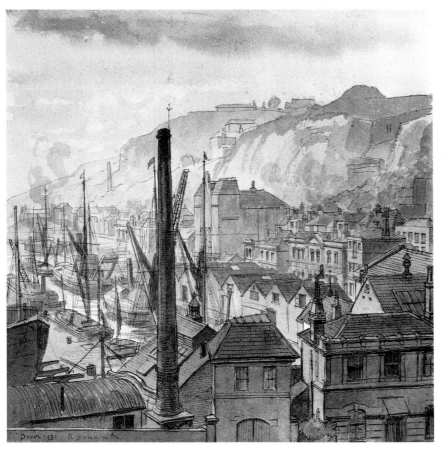

Kinetic landscapes

The land which had been burned and blackened
by the Victorians was further disfigured by pylons, hoardings
and ribbon development, although some artists began to discern
a new type of kinetic landscape among the reflected
lights of the arterial roads.

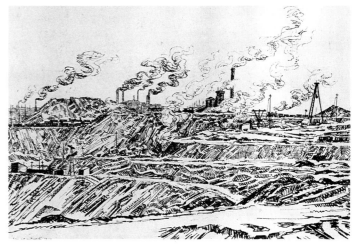

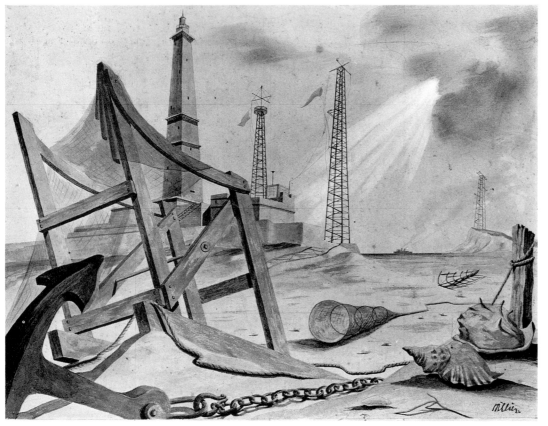

85 Randolph Schwabe, *Dover*. Pen and
watercolour, 1931.

86 Edward Wadsworth, *Black Country*.
Pen, 1919.

87 Tristram Hillier, *Beach Scene with Radio
Masts*. Pen and wash on paper, c.1934.

Opposite.

88 Julian Trevelyan, *The Potteries*. Oil on
canvas, 1938.

89 Vivian Pitchforth, *Night Transport*. Oil
on canvas, 1939–40.

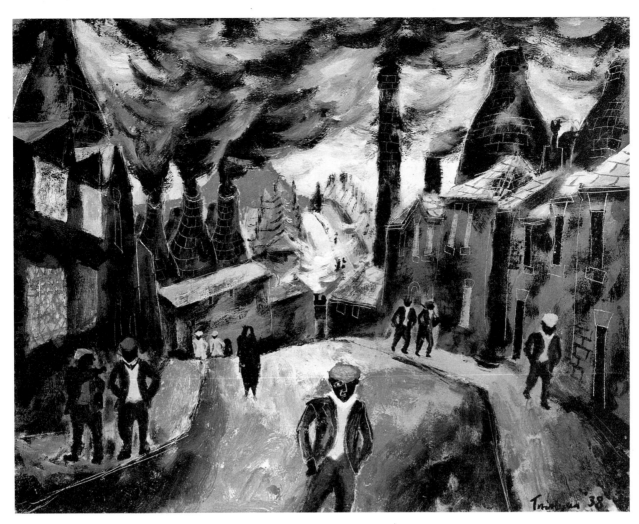

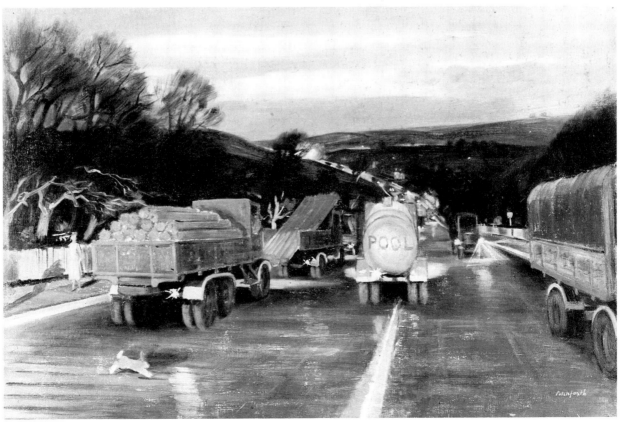

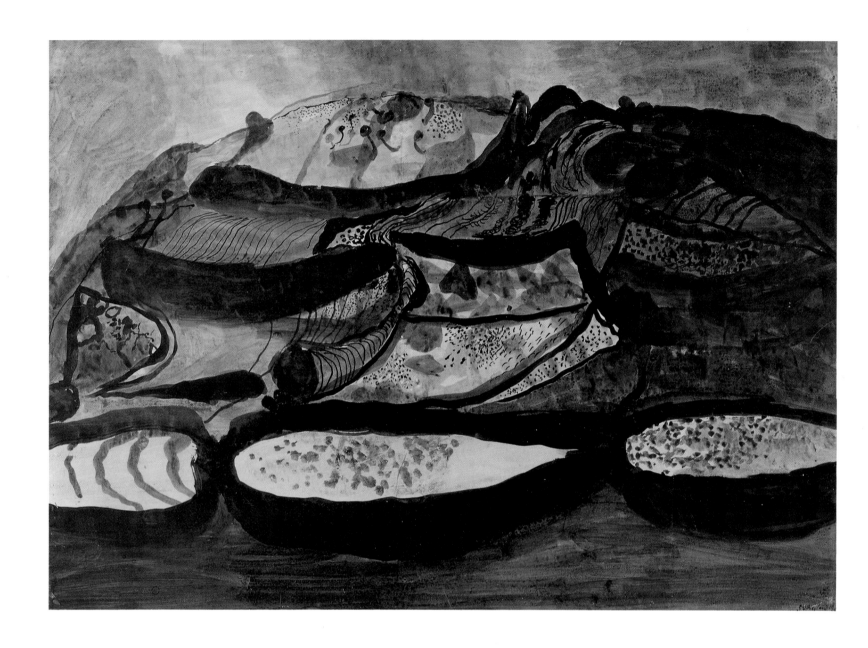

The oceanic impulse

Breaking waves and bird flight
express a larger rhythm running through creation,
a rhythm picked up in the flowing movements
of Sutherland's dark hill.

90 Graham Sutherland, *The Dark Hill*
(Landscape with Hedges and Fields). Watercolour, 1940.

91 Julius Olsson,
Dunluce Castle, Northern Ireland.
Poster, 1924.

92 Winifred Nicholson, *Sandpipers, Alnmouth.*
Oil and sand on board, 1933.

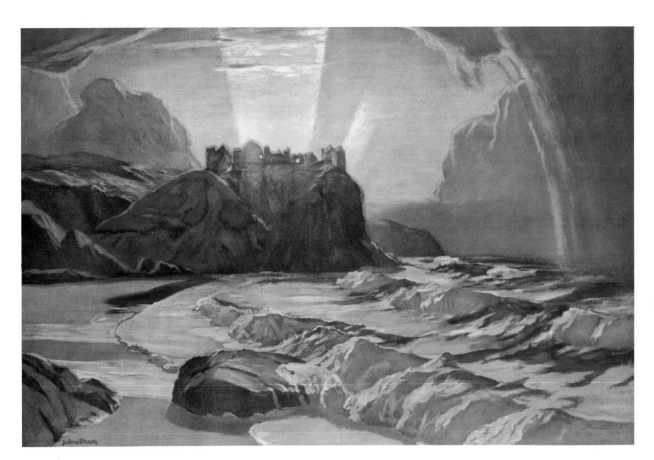

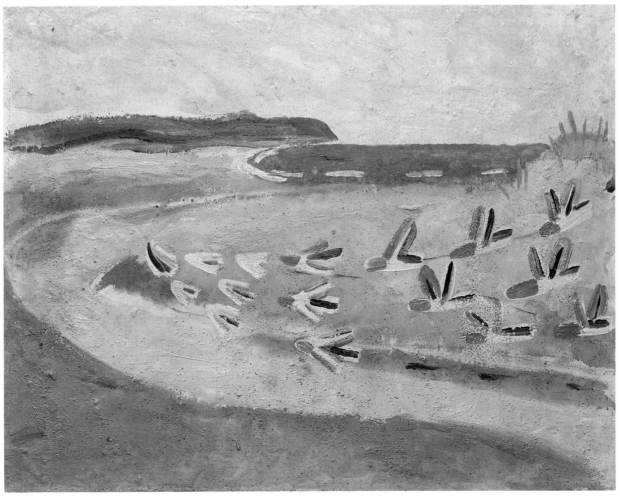

Hills of dreams

For artists, writers and politicians,
ancient walls and earthworks stood as reminders
of a spiritual past and were incentives to
dream away the prosaic present.

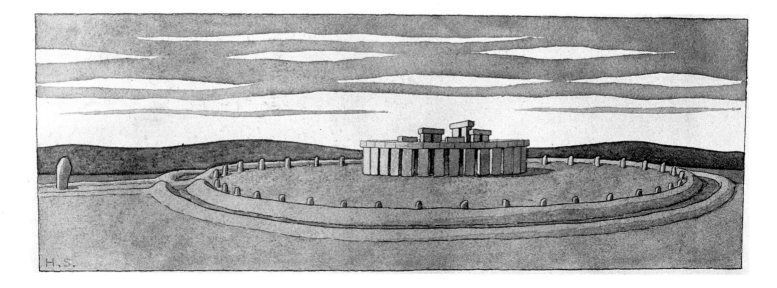

93 Charles Gere, *British Camp, Malvern*. Pencil and watercolour, *c*.1943.

94 Heywood Sumner, *Stonehenge*. Watercolour, *c*.1920.

95 Bill Brandt, *Roman Wall*. Gelatin silver print, 1944.

96 Clifford Webb, *Roman Wall*. Wood engraving from Thomas Balston, *English Wood-engraving, 1900–1950*, 1951.

97 Leslie Ward, *The Long Man on the Downs*. Woodcut, *c*.1930.

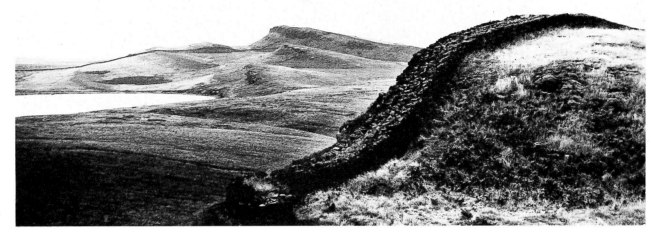

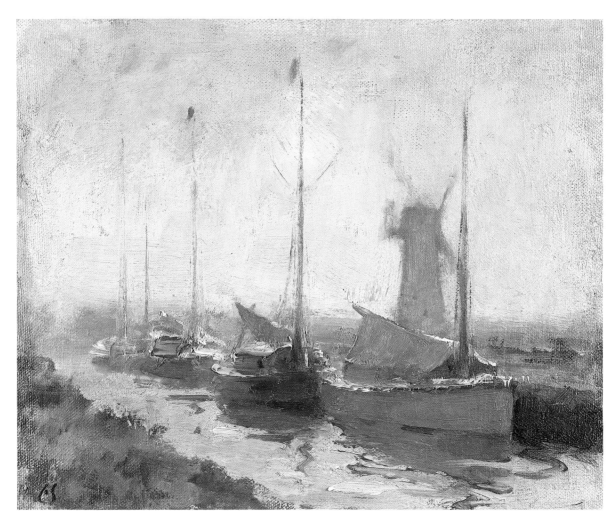

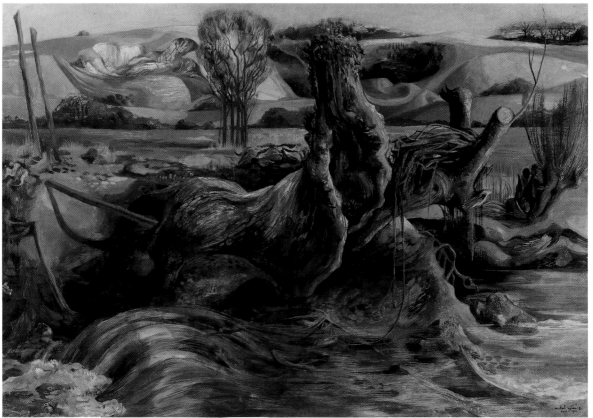

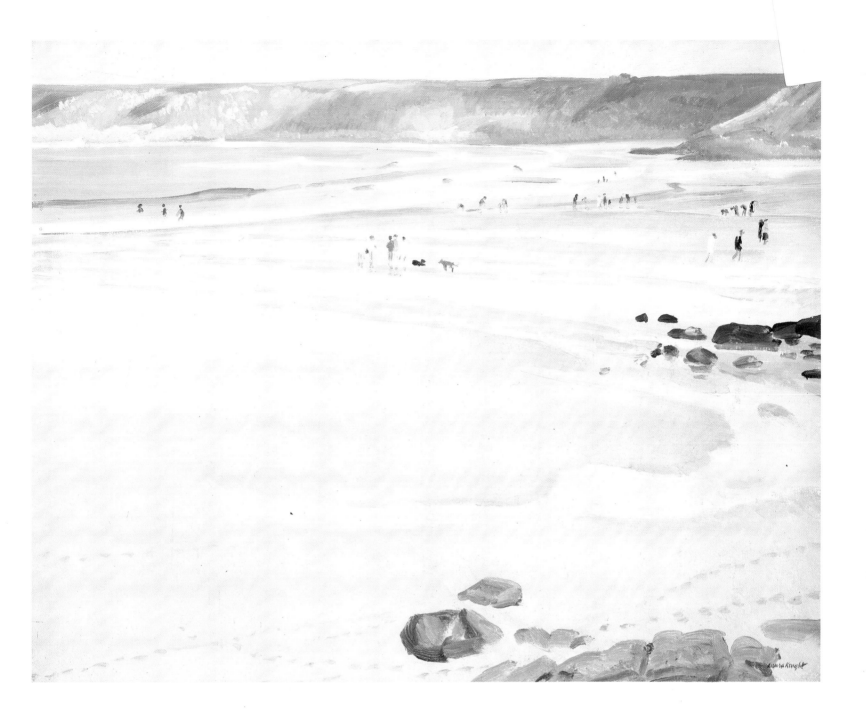

Mists and waters

Figures become marks on a wide shore,
boats merge into the mist, a twisting stream is answered
by the spiralling bole of a tree and a flowing hillside.
Shapes strive towards an original flux
of mist, light and water.

98 Edward Seago, *Evening Haze, Thurne Dyke*.
Oil on canvas board, before 1952.

99 Michael Ayrton, *Winter Stream*.
Oil on canvas, 1945.

100 Dame Laura Knight, *Sennen Cove, Cornwall*.
Oil on canvas, c.1926.

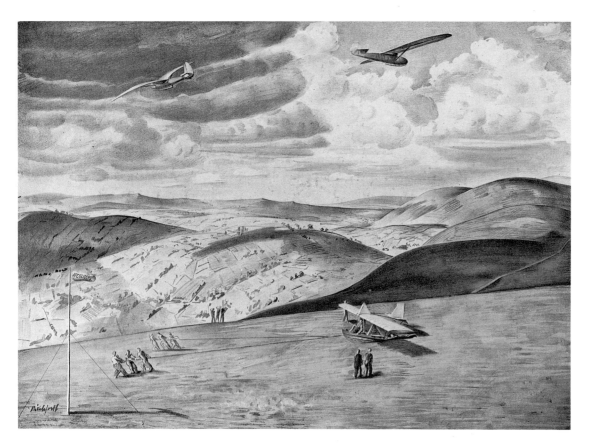

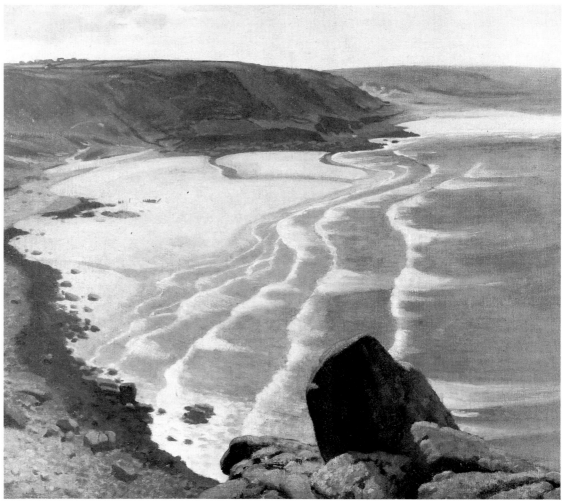

101 Vivian Pitchforth, *Gliding*.
Watercolour, 1942.

102 Harold Knight, *Whitesands Bay,
Cornwall*. Oil on canvas, c.1930.

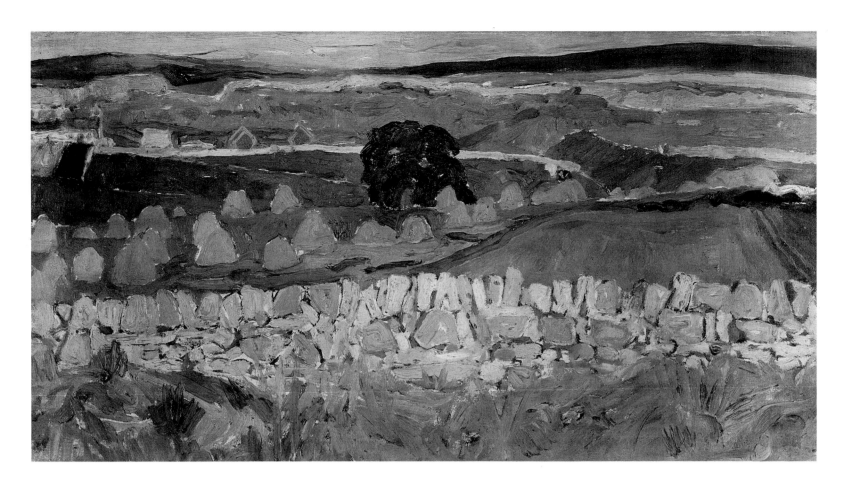

103 W. G. Gillies, *Esperston*.
Oil on canvas, 1950.

104 Victor Pasmore, *Beach in Cornwall*.
Pen and ink on card, 1950.

105 Edwin Smith, *Derbyshire, near Sparrowpit*.
Gelatin silver print, *c.*1950.

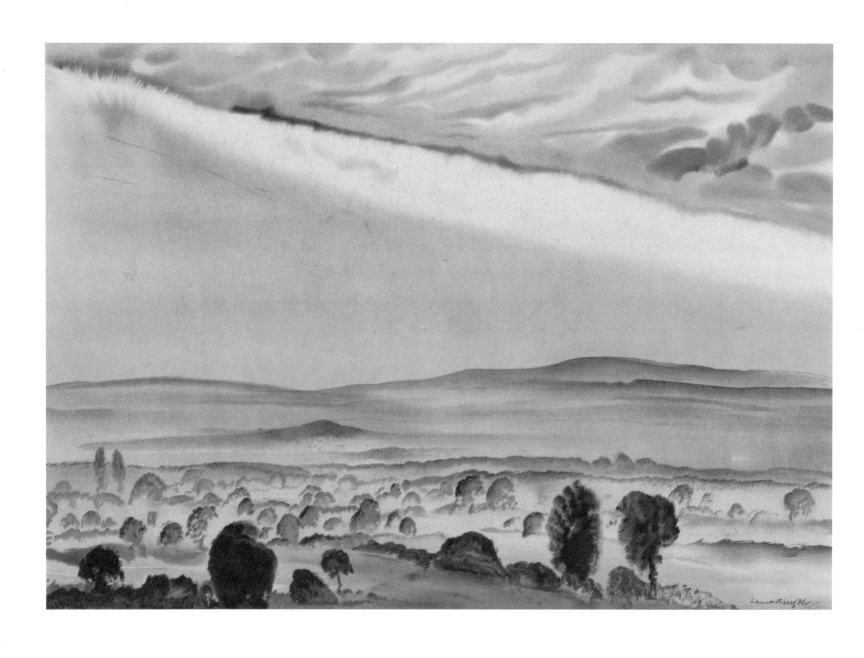

106 Dame Laura Knight, *September Radiance*. Poster, 1937.

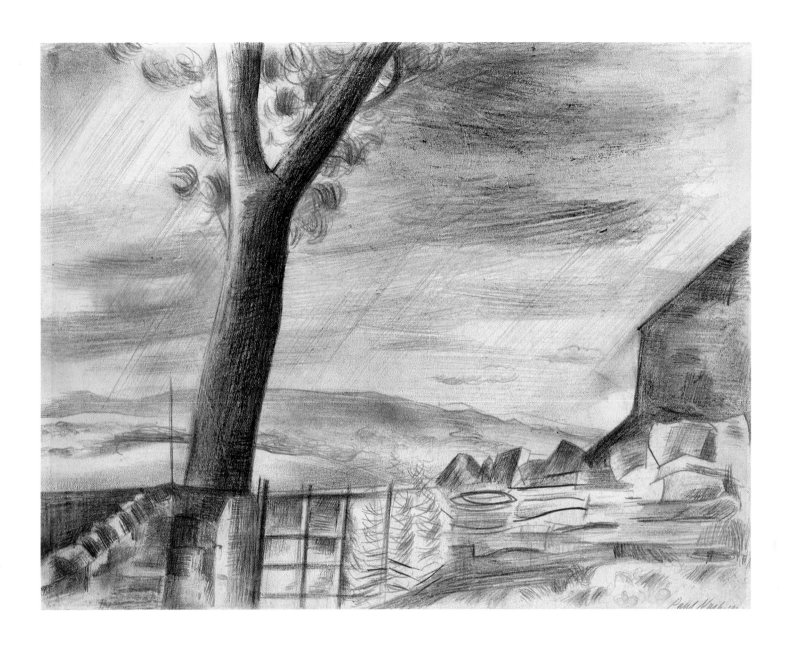

107 Paul Nash, *Trees and Cottages, Cumberland*. Pencil and coloured chalks on white wove, 1924.

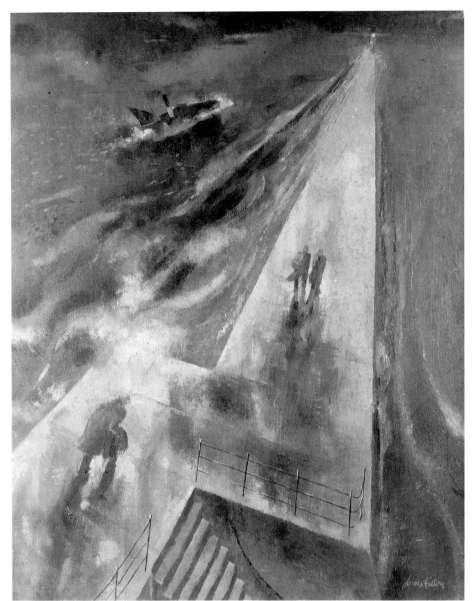

In the wind and rain

Erratic weather put an onus on the artist as a skilled observer and recorder, but at a deeper level was celebrated as an expression of the turbulent and ungovernable spirit of the place.

108 James Fitton, *The Breakwater*. Oil on canvas, c.1940.

109 Stephen Bone, woodcut from Gertrude Bone, *Of the Western Isles*, 1925.

110 Eric Ravilious, head-piece for 'January'. Wood engraving from N. Breton, *The Twelve Moneths*, 1927.

111 D. P. Bliss, *Lovers Sheltering from a Storm*. Wood engraving, c.1926.

112 Thomas Hennell, *Landscape near Ridley, Kent*. Watercolour, c.1943.

113 Victor Pasmore, *The Quiet River: The Thames at Chiswick*. Oil on canvas, 1943–44.

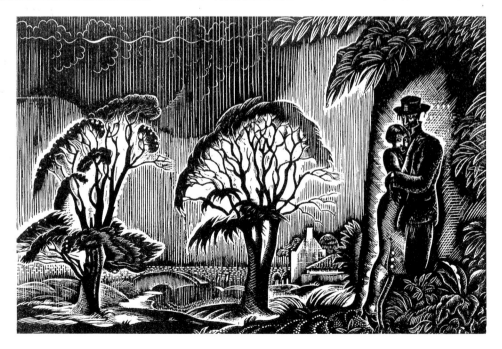

Modern motifs

The plain, geometrical shapes of beached boats,
jetties and sheds were appreciated by painters and designers
because they hinted at an alignment and reconciliation of
ancient and modern, old landscape and new design.

114 Edward Bawden, *September Noon*. Watercolour, 1937.

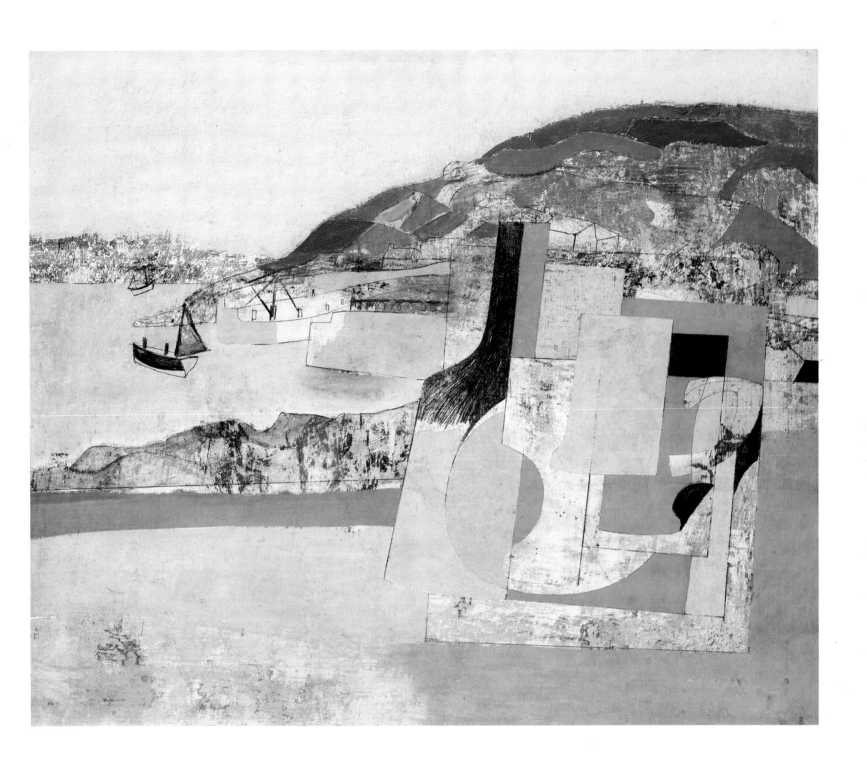

115 Ben Nicholson, *Mousehole*. Oil and pencil on canvas, mounted on wood, 1947.

"Heaven's gate opens when the world's is shut."

The road runs on. The bus will take you down the road.
You can see the gate, but the bus cannot take you through.

As near to heaven as ever you will be!

Light: sacred and secular

Rays of directed light cut through many images of the land and
show unruly or profuse nature subject to an order often more
modern and imposed than God given.

116 Paul Woodroffe, *Heaven's
Gate Opens when the World's
is Shut*. Design for a poster.
Process engraving, 1927.

117 Eric Ravilious, wood
engraving from Martin Armstrong
Fifty-four Conceits, 1933.

118 Robin Tanner, *Martin's Hovel*.
Etching, 1927.

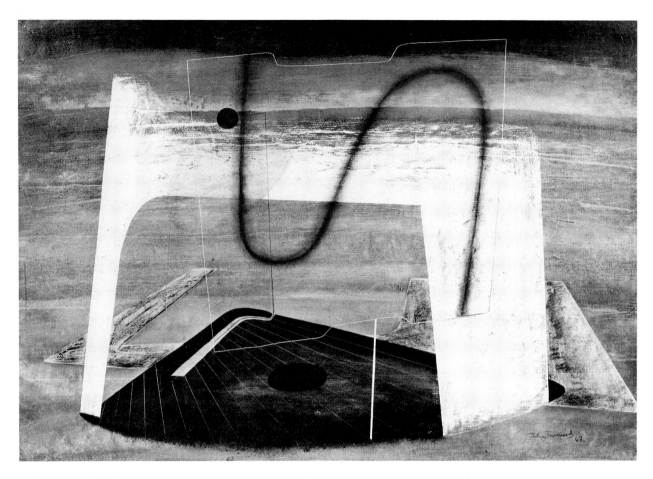

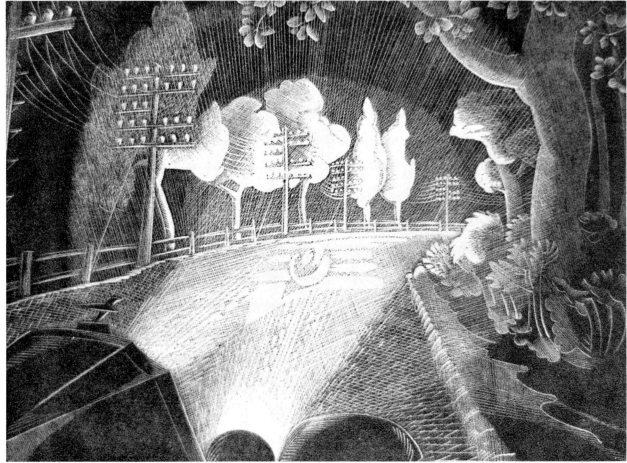

119 John Tunnard, *Cornwall*.
Oil on board, 1942.

120 Gertrude Hermes,
Through the Windscreen.
Wood engraving, 1926.

Hills of fire

Such hills as these commemorate great days
in England's history. Macaulay, in *The Armada*,
imagined England rallying to arms, responding to 'twinkling
points of fire', a warning radiance relayed from
beacon to beacon across the country.

121 Gilbert Spencer, *Melbury Beacon*. Oil on canvas, *c*.1937.

122 Charles Knight, *Ditchling Beacon*. Oil on canvas, c.1950.

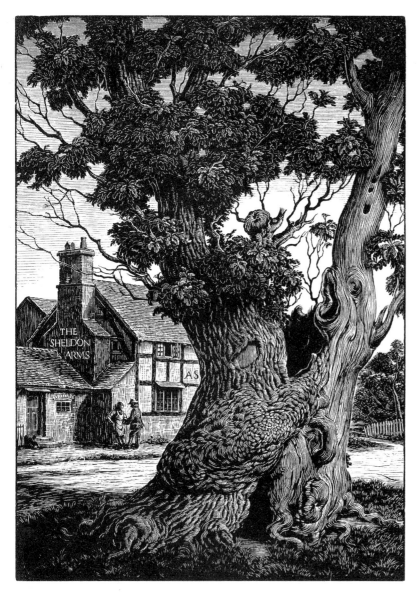

123 Joan Hassall, *The Stricken Oak*. Wood engraving from Francis Brett Young, *Portrait of a Village*, 1937.

124 Heywood Sumner, *The Road Through Mark Ash*. Illustration from Heywood Sumner, *A Guide to the New Forest*, 1924.

125 Eric Ravilious, wood engraving from *The Writings of Gilbert White of Selborne*, 1938.

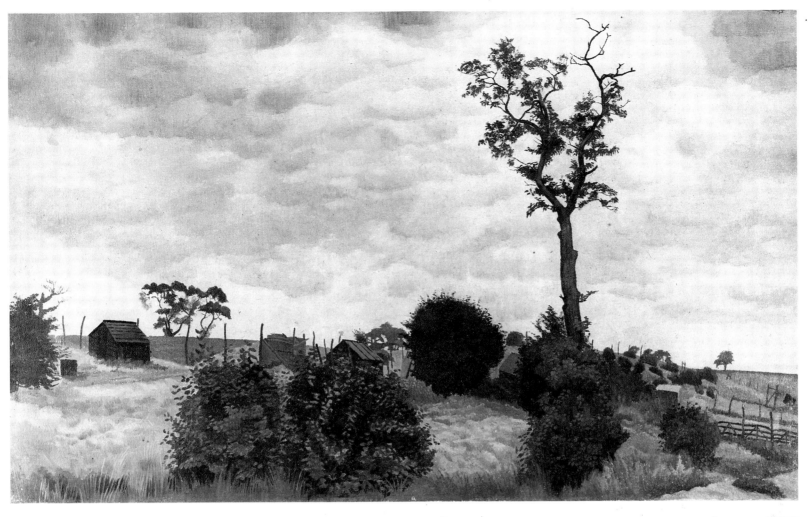

Sacred groves

On the village greens and in the forests of
an imagined and actual Britain, riven oaks,
survivors of lightning and bad weather,
symbolized endurance. The woods themselves
promised danger and hinted
at freedom.

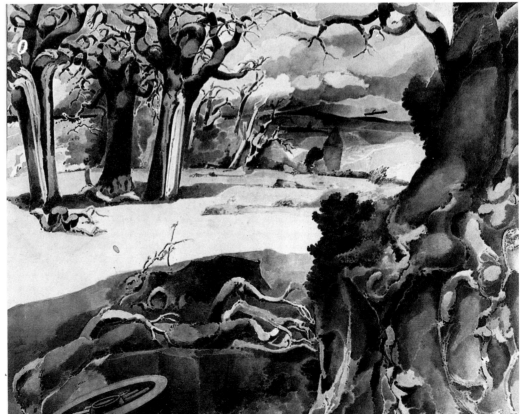

126 Stanley Spencer, *Tree and Chicken Coops,
Wangford*. Oil on canvas, 1925.

127 Edward Burra, *Blasted Oak*. Watercolour,
1942.

Primal scenes

Contact with the elements brought suggestions of
grandeur and a return to origins. Michael Ayrton sets
his Joan against a modern Adam and Eve, while Josef Herman envisages
his miners imbued with the severe and muscular
qualities of their harsh environment.

128 Michael Ayrton, *Joan in the Fields*. Oil on panel, 1943.

129 Josef Herman, *Autumn*. Watercolour, 1946.

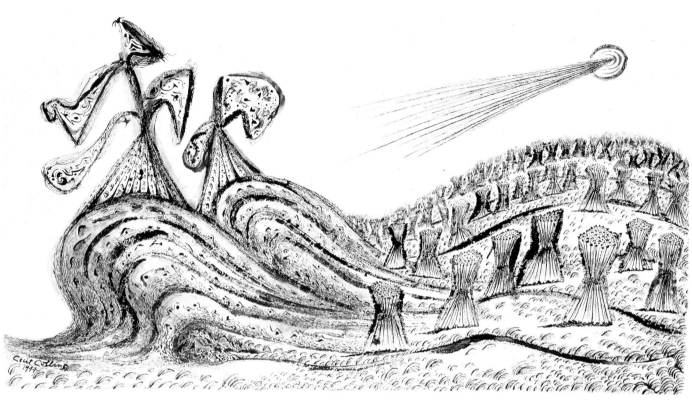

Heaven and earth

The earth, according to Neo-Platonic theory, was originally no more than a heap of jarring atoms, but responded to patterns established by the stars and planets. Thus the earth's forms reflect those of the heavens, as Nash's woods rhyme with the sun and moon.

130 Cecil Collins, *The Field of Corn*. Pen and ink, wash and watercolour, 1944.

131 Paul Nash, *Pillar and Moon*. Oil on canvas, 1932–42.

132 Paul Nash, *Landscape of the Vernal Equinox*. Oil on canvas, 1943.

133 Edwin Smith, *Chatsworth, from the Terrace*. Gelatin silver print, c.1950–59.

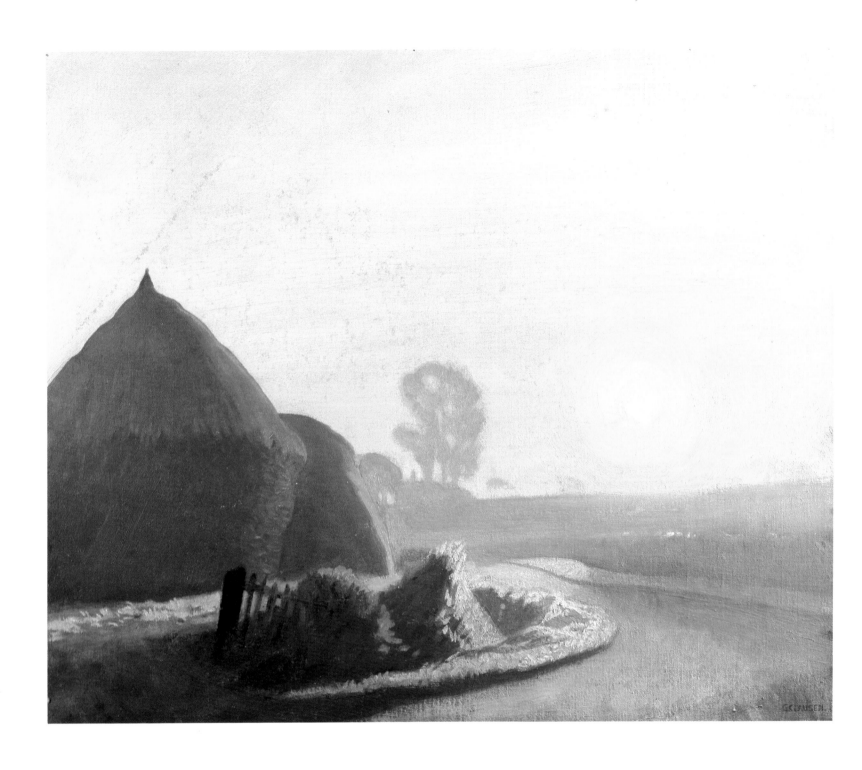

134 George Clausen, *Sunrise*. Oil on canvas, c.1924.

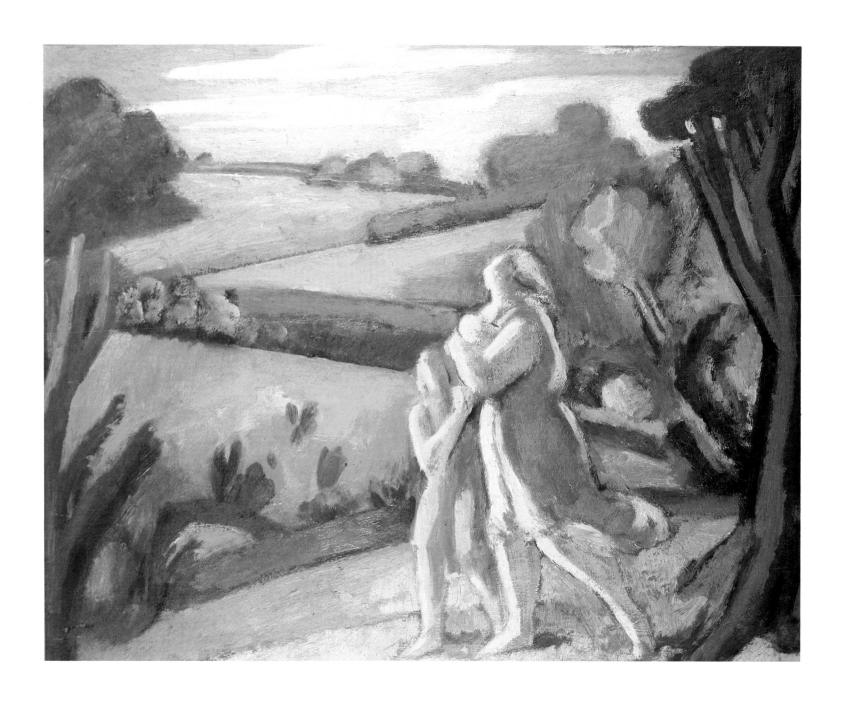

135 Bernard Meninsky, *The Journey*. Oil on canvas, 1936–39.

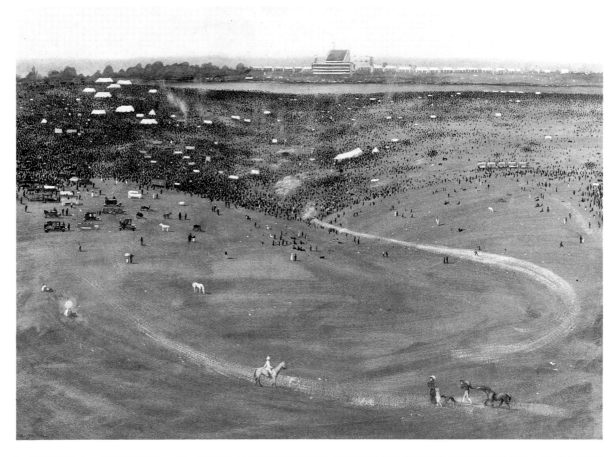

Landscape and history

While Derby Day brings together the extremes of British society, Newton's panorama shows all assimilated into the flowing downland. Similarly in Eurich's air battle, the wide sky and sea envelop history both made and in the making.

136 Algernon Newton, *The Derby 1920*. Watercolour.

137 Richard Eurich, *Air Fight over Portland*. Oil on canvas, 1940.

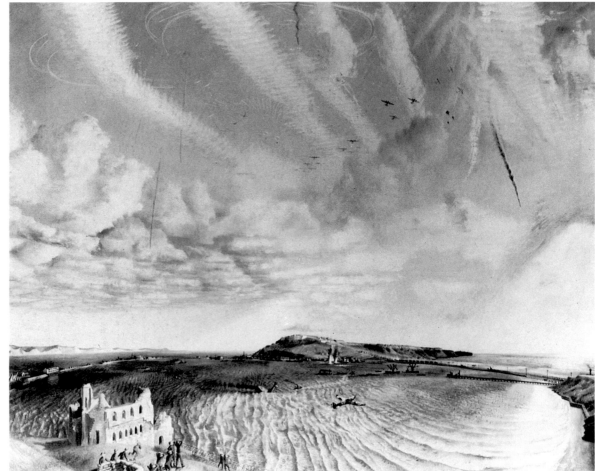

BIOGRAPHIES AND NOTES
ON THE ILLUSTRATIONS

INDEX

Margaret Webb, wood engraving
from John Claridge, *The Country Calendar*, 1946.

BIOGRAPHIES AND NOTES ON THE ILLUSTRATIONS

Dimensions are given in inches and centimetres, height before width.

ALLEN, Harry Epworth 1894–1953

Allen was born in Sheffield, and trained at Sheffield College of Art. He lost a leg during the Great War, which hindered his work as a landscape painter. He painted mainly in Derbyshire, in the White Peak area around Buxton.

29 *Hathersage, Derbyshire*, $19\frac{7}{8}$ × 25 (50.4 × 63.4). Laing Art Gallery, Newcastle-upon-Tyne.

AYRTON, Michael 1921–75

Michael Ayrton was born in London, where his mother, Barbara Ayrton, was Labour MP for North Hendon. His schooling was interrupted by long periods of illness. In 1936 he spent six months in Vienna studying drawings at the Albertina. In the autumn of 1938 he moved to Paris where he shared a studio with John Minton. His early supporters included Jack Beddington, the Art Director of Shell, and Sir Hugh Walpole, the writer. Walpole introduced him to John Gielgud who asked him to design the scenery and costumes for *Macbeth*, staged in 1942. After being invalided out of the RAF in 1942 he taught, and for a while was art critic for *The Spectator*. In 1944 one of his subjects included the great yew wood at Odstock in Oxfordshire, a characteristically mysterious Neo-Romantic site of the sort discussed by Peter Inch in his article 'Unkempt Growth and Layers of Time', *Landscape* (Berkeley, No. III, Vol. 26, 1982). Ayrton thought in terms of empathy with nature: 'To paint the essentials of a tree one must come to understand what it is to be a tree, and must become the tree one is painting' (1946). His work is surveyed by Peter Cannnon-Brookes in the catalogue *Michael Ayrton* (Birmingham City Museum and Art Gallery, 1977).

99 *Winter Stream*, $22\frac{1}{2}$ × $32\frac{3}{4}$ (57.2 × 83.2). Aberdeen Art Gallery and Museums.

128 *Joan in the Fields*, 19 × 24 (48.3 × 61). Private Collection.

BATEMAN, James 1893–1959

Bateman was born at Kendal, Westmoreland, into a farming community, and between 1910 and 1914 studied sculpture at Leeds School of Art.

Injuries sustained during the Great War forced him to give up sculpture for painting, and between 1919 and 1921 he was a student at the Slade School of Fine Art. Between 1922 and 1928 he taught at Cheltenham School of Art, and it was in those years that he painted *Pastoral*, at Little Witcombe in the Cotswolds, within cycling distance of Cheltenham. He exhibited successfully at the Royal Academy from 1924.

69 *Haytime in the Cotswolds*, 42 × $52\frac{5}{8}$ (106.8 × 133.8). Southampton Art Gallery.

72 *Pastoral*, 39 × 72 (99.1 × 182.9). The Tate Gallery, London.

BAWDEN, Edward b.1903

Bawden studied at the Cambridge School of Art and at the Royal College of Art where he gained a Diploma in Book Illustration in 1925. Increasingly interested in landscape, he first visited Great Bardfield in Essex in 1930, and by 1932 he and his wife had settled there with the Ravilious family at Brick House. Bawden's *Gardener's Diary*, which he decorated for Country Life in 1937, celebrates the Brick House Garden. He was the subject of J. M. Richards's *Edward Bawden* (London, 1946), published in the year he illustrated M. G. Lloyd Thomas's *Travellers' Verse* in the 'New Excursions into English Poetry' series. More of his lithographs appear in *Life in an English Village* (London, 1949).

114 *September Noon*, $17\frac{1}{2}$ × 22 (44.5 × 55.9). Victoria and Albert Museum, London.

BEATON, Sir Cecil 1904–80

Educated at Harrow and Cambridge, Cecil Beaton was interested in photography from childhood. Encouraged by Osbert Sitwell, he became a full-time photographer. His influences included the Sitwells, Surrealism and Diaghilev. In the 1920s he began to work for *Vogue*, and in 1930 Duckworth published his *Book of Beauty*. In the mid 1930s he took Ashcombe on a long lease, 'a very remote and romantic house situated among the most beautiful woods in the Wiltshire Downs.' He stayed there until 1945 and then lived at Reddish House in Broadchalke, also in

Wiltshire. At Broadchalke he recorded 'the changes that took place from week to week in the gardens and the surrounding woods'. That part of his life is recounted in *Photobiography* (London, 1951).

17 *Country Still-life with Eggs*, $8\frac{1}{2}$ × $7\frac{3}{4}$ (21.6 × 19.5). Cecil Beaton photograph, courtesy of Sotheby's, Belgravia.

BELL, Walter b.1904

Bell was born in Sheffield and trained at Sheffield College of Art. He worked as a hairdresser and painted on a part-time basis. *Derbyshire Quarry* was exhibited at the Royal Academy in 1937. He moved to Cornwall and became a full-time painter, relying for his income on the tourist trade.

78 *Derbyshire Quarry*, 25 × 30 (63.5 × 76.2). Sheffield City Art Galleries.

BLISS, Douglas Percy b.1900

Bliss was born in Karachi, where his father was a trader. On the painting course at the Royal College of Art between 1922 and 1925 he came to know Eric Ravilious and Edward Bawden. He attended print-making classes and produced wood engravings for *Border Ballads* (London, 1925) and then wrote *A History of British Wood Engraving* (London, 1928). He taught from the early 1930s onwards and became Director of the Glasgow School of Art. He took his vacations on the Isle of Barra, in the Outer Hebrides, and painted there.

28 *February in My Garden*, 30 × 40 (76.2 × 101.6). D. P. Bliss.

47 *Crofts in the Quirang, Isle of Skye*, 12 × $19\frac{1}{2}$ (30.5 × 49.5). Blond Fine Art, London.

111 *Lovers Sheltering from a Storm*, $4\frac{1}{8}$ × $6\frac{1}{4}$ (10.5 × 15.9). Blond Fine Art, London.

BOMBERG, David 1890–1957

Bomberg was born in Birmingham of Polish immigrant parents. Between 1908 and 1910 he studied book production and lithography at the Central School of Arts and Crafts in London.

Between 1911 and 1913 he was at the Slade School of Fine Art where he developed a simplified 'Cubist' style: 'I APPEAL to a *Sense of form . . . I am searching for an Intense* expression . . . where I use Naturalistic Form, I have *stripped it of all* irrelevant matter.' (From a manifesto of 1912.) He served in the Great War, then lived in the country and bred turkeys before working in Palestine between 1923 and 1927. His Palestine paintings are often quite naturalistic. Afterwards he developed a more expressive idiom, subjectively determined by his own consciousness of mass, gravity and density of texture. He was an influential teacher at the Borough Road Polytechnic in the 1940s. His work has elicited fine critical writing by Andrew Forge and David Sylvester in Arts Council of Great Britain catalogues of 1957 and 1967 respectively.

81 *St Paul's and River*, 20 × 25⅛ (50.8 × 63.8). The Tate Gallery, London.

BONE, Stephen 1904–58

Born at Chiswick, the son of the illustrator Sir Muirhead Bone, Stephen Bone was educated at Bedales and then at the Slade School of Fine Art. In 1925 his woodcuts were used to illustrate a book by his mother Gertrude Bone, *Of the Western Isles*. In the 1930s he prepared the twelfth Shell Guide, *The West Coast of Scotland*. His book *Albion: An Artist's Britain* (London, 1939) is a study of the British context, dealing with 'The Weather and The Seasons', and 'The Traveller and The Industrial Landscape'. In it he spoke up for the car: 'The car is freedom . . . it is a joy to feel that one's fate is more or less in one's own hands.' He gave an appreciative account of British art and landscape in *British Weather* (London, 1946).

109 Woodcut from Gertrude Bone, *Of the Western Isles* (London, 1925).

BRANDT, Bill 1904–83

In his mid twenties Brandt spent four years as assistant to the photographer Man Ray in Paris. During the 1930s most of his work was documentary and reportage, with Surrealist undertones; he was particularly influenced by De Chirico. In 1937 he visited the North of England and reported on grim conditions in Jarrow, Sheffield, the Potteries, Halifax and Newcastle. In 1941 he took documentary pictures of architecture for the National Buildings Record, comparable to John Piper's contemporary views of England as a land of romantic ruins. *Literary Britain*, first published in 1951, contains his major work in landscape; in it he interprets Britain in terms of a few strongly modelled objects, such as turrets, rock outcrops, thatched roofs, gables and standing stones, mostly set against distant hills, woods and horizons. His other principal photographic books are *The English at Home* (London, 1936), *A Night in London* (London, 1938) and *Camera in London* (London, 1948). An analysis of his photography by David Mellor appears in the exhibition catalogue *Bill Brandt* (R.P.S. National Centre of Photography, London, 1981).

95 *Roman Wall*. Copyright © Bill Brandt.

BROWN, F. Gregory 1887–1948

A commercial artist and textile designer, Brown was apprenticed to an art metalworker in 1903, but abandoned that for illustration. In 1915 he designed War Savings posters, and between 1924 and 1938 posters for the London Passenger Transport Board and for the Southern Railway.

20 *Dorking*. Design for a poster advertising the London General Omnibus Company Ltd, 21 × 19½ (53.3 × 49.5). Victoria and Albert Museum, London.

BURRA, Edward 1905–76

As a child Burra suffered from anaemia and rheumatic fever, and on leaving school at fourteen spent most of his time drawing and painting. He went to Chelsea School of Art, and then to the Royal College of Art in 1922. He lived most of his life in the family home at Rye, and in the mid 1920s came to know Paul and Margaret Nash who lived nearby at Iden; in 1930 he spent a six-week holiday with the Nashes in the South of France and 'proved at times an alarming fellow traveller.' He travelled to Mexico and to New York in 1934 and to Spain in 1935 and during the Civil War. His favourite theme was urban landscape, and he was especially interested in low life, in the ghostly and the bizarre. His landscapes feature strongly marked and isolated pieces of industrial equipment, and writhing, visceral elements as in *Blasted Oak*.

127 *Blasted Oak*, 19¾ × 24¼ (50.1 × 16.6). The Arts Council of Great Britain, London.

CLAUSEN, Sir George 1852–1944

Clausen was trained at the National Art School in South Kensington and in Paris. He began to exhibit pictures of country life at the Royal Academy in the 1870s, and continued to favour rural subjects throughout his long career. In his early pictures painted at Cookham Dean in Berkshire, the human figure predominates. In 1891 he went to live in Essex, close to Saffron Walden, and began increasingly to show his field workers assimilated into broad landscape settings and subordinated to effects of light. In his art he acknowledged what he called 'the beauty of the great elementary things – the sky, sunshine, and the hills, rivers, fields, and trees'. For a very full account of Clausen's distinguished career, see Kenneth McConkey's catalogue, *George Clausen, R. A.* (Bradford Art Galleries and Museums and Tyne and Wear County Council Museums, 1980).

134 *Sunrise*, 24 × 30 (61 × 76). Fine Art Society, London. Photo courtesy of Sotheby's, London.

COLLINS, Cecil b.1908

Born at Plymouth in Devon, Collins started to draw at an early age, influenced by the landscape and seascape of his native county. In 1923 he won a scholarship to the Plymouth School of Art. Between 1927 and 1931 he studied at the Royal College of Art. At first he was influenced by Surrealism and exhibited at the International Surrealist Exhibition in 1936, in which year he also withdrew from London and went to live in Totnes, Devon. His interest in the art and philosophy of the Far East was stimulated by a meeting with an American artist, Mark Tobey, in 1938. He returned to London in 1943 and began to write his essay *The Vision of the Fool*, a discussion of 'the artist, the poet and the human being and their relation to the increasingly mechanised environment of modern civilisation.' After the war he travelled widely and became involved in tapestry design. His work is emphatically symbolic, self-contained and fully articulated, and it is beautifully introduced by Christopher Middleton in an exhibition catalogue, *Cecil Collins* (Whitechapel Art Gallery, London, 1959).

130 *The Field of Corn*, 15⅜ × 22½ (39 × 57.2). Victoria and Albert Museum, London.

COOK, Brian b.1910

Brian Cook was born at Gerrards Cross, Buckinghamshire, and studied painting at Repton under Arthur Morris. In 1928 he went to the Central School of Arts and Crafts in London, where he studied under the draughtsman John Farleigh and the wood engraver Noel Rooke. He was employed by the publishing firm of Batsford from 1928, and throughout the 1930s contributed pen and ink illustrations to their 'English Heritage' series, and designed over 200 book jackets. He specialized in the use of the Jean Berté printing process using hand-cut rubber plates and watercolour inks. The brilliance of colour he thus achieved became widely familiar as the trademark of the Batsford *Books on Britain*. A detailed biography appears in the catalogue *Landscape in Britain 1850–1950* (The Arts Council of Great Britain, London, 1983).

21 Design for the dust jacket of C. B. Ford, *The Landscape of England* (London, 1933), 9⅞ × 14¾ (25 × 37.5). Private Collection.

COXON, Raymond b.1896

Coxon studied at Leeds School of Art and then at the Royal College of Art in London. In 1926 he married the painter Edna Ginesi and in 1927 he formed, with Henry Moore and others, the short-lived British Independent Society. In his book *Art* (London, 1932), he discussed painting in relation to modern society and to advertising with its invitation 'to partake of the joys of a latter-day Arcady made by Business, a land of pure delight where everything is as you like it and where new desires are created for your special benefit.' He

was an official war artist, and in the 1940s designed posters for the Council for the Encouragement of Music and the Arts.

74 *October Tree-felling.* Poster for the Council for the Encouragement of Music and the Arts, 31½ × 40½ (80 × 103). Amenities Department, Kettering Borough Council.

DISMORR, Jessica 1885–1939
Between 1910 and 1913 Jessica Dismorr studied in Paris at the Atelier La Palette, where the teachers included Metzinger and Segonzac. At first she was a Fauve painter but by 1914 was a member of the Vorticist Group, whose dynamic, near-abstract style influenced her into the 1920s. In 1926, however, she was elected to the relatively conservative and provincial 7 & 5 Society.

26 *Folkestone Harbour*, 14¾ × 10⅞ (37.5 × 27.7). Anthony d'Offay Gallery, London.

DU PLESSIS, H. E. b.1894
The son of a clergyman, Du Plessis was born in the Transvaal. He was a London correspondent for South African papers and began to paint around 1927. He had no art schooling, but became a member of the London Artists' Association and of the London Group.

30 *Mecklenburgh Square*, 18¼ × 24½ (46.3 × 62). Southampton Art Gallery. Photo Courtauld Institute, London.

DUNBAR, Evelyn 1906–60
Evelyn Dunbar studied at Rochester and at Chelsea Schools of Art and then at the Royal College of Art between 1929 and 1933. In 1937, with Cyril Mahoney, she wrote and illustrated *Gardeners' Choice*, in which traditional terrain is given a modern appearance. Farming provided her with an even better opportunity to relocate modern idioms in a traditional context when in 1942 she illustrated Michael Greenhill's *A Book of Farmcraft* with aerial views of side delivery hay rakes in action and cross-sections of ploughed land 'cast' and 'gathered'. In 1956 she recorded this of *A Land Girl and the Bail Bull*, painted when she was an official war artist: 'It is an imaginative painting of a Land Girl's work with an outdoor dairy herd on the Hampshire Downs. The bail is a movable shed where the milking is done. Soon after dawn in the early summer the girl has to catch and tether the bull: she entices him with a bucket of fodder and hides the chain behind her, ready to snap on the ring in his nose as soon as it is within her reach – a delicate and dangerous job.'

70 *A Land Girl and the Bail Bull*, 36 × 72 (91.4 × 182.9). The Tate Gallery, London.

ELLIS, Clifford b.1907
ELLIS, Rosemary b.1910
Clifford and Rosemary Ellis married in 1931 and collaborated during the 1930s as designers. They produced over twenty posters and bills for the London Passenger Transport Board. Their posters for Shell-Mex and BP included *Whipsnade Zoo* in 1932 and *Antiquaries Prefer Shell*, which initiated the 'Professions' series in 1934. (In 1934 John Betjeman praised Shell-Mex and BP for 'furthering that interest in English scenery which their many excellent posters have encouraged, and acting with the disinterestedness which caused them to take down disfiguring tin signs some years ago.') From 1945 to 1982 Clifford and Rosemary Ellis designed nearly a hundred book jackets for the 'New Naturalist' series published by Collins.

57 *Antiquaries Prefer Shell*, 22⅜ × 38¼ (56.6 × 97). Private Collection.

EURICH, Richard Ernst b.1903
Eurich was born and educated in Bradford and attended Bradford School of Art which emphasized commercial art and design. Between 1924 and 1927 he studied at the Slade School of Fine Art. His early paintings were highly finished, but in 1929 he met Christopher Wood and for a number of years afterwards painted broadly handled coastal scenes, from the Dorset area particularly. In 1940 he reverted to a detailed style in a number of panoramic pictures of the war. His career is surveyed by Caroline Krzesinska in the exhibition catalogue *Richard Eurich, R.A.* (Bradford Art Galleries and Museums, 1980).

137 *Air Fight over Portland*, 30 × 40 (76 × 101.5). Imperial War Museum, London.

FITTON, James 1889–1982
Fitton was born in Oldham. Between 1913 and 1919 he was apprenticed to a fabric designer and attended evening classes at Manchester School of Art. In 1920 he moved to London where he took evening classes in drawing under A. S. Hartrick at the Central School of Arts and Crafts. His paintings of the 1930s include several of Kentish oast houses as well as many in a social realist vein. Under the pseudonym Alpha he contributed cartoons to *The Daily Worker*. In the Second World War he designed posters for the Ministry of Food: 'A Clean Plate Means a Clear Conscience'. An affectionate account of his career is given by Sidney C. Hutchison in the exhibition catalogue *James Fitton* (Oldham Art Gallery, 1983).

108 *The Breakwater*, 30¼ × 25 (76.8 × 63.5). The Arts Council of Great Britain, London.

FREEDMAN, Barnett 1901–58
Freedman was born in London's East End, to Russian immigrant parents. In 1916 he became a draughtsman for a firm of monumental masons, and for five years attended evening classes at St Martin's School of Art, before moving to the Royal College of Art in 1922. His chief achievements were in lithography and book illustration, although he also designed advertisements, posters and stamps. His main patrons were the Curwen and Baynard Presses and Faber and Faber, for whom he designed many book jackets. Although he drew and painted landscape and numbered many serious landscapists among his friends, he said, 'There's nothing I hate more than fresh air and wide open spaces.' Some biographical details appear in the exhibition catalogue *Barnett Freedman* (The Arts Council of Great Britain, 1958).

61 *Caves Farm*, 14 × 18½ (35.7 × 47). The Arts Council of Great Britain, London.

FRY, Roger 1886–1934
Fry studied Natural Sciences at King's College, Cambridge. Interested in painting, he enrolled at the Académie Julian in Paris in 1891. He began to review in 1892, writing on Bellini and Giotto. In 1906 he felt the impact of Cézanne's art, and in 1910 widened the horizons of British artists when he organized the exhibition *Manet and the Post-Impressionists* at the Grafton Galleries in London, followed in 1912 by a second Post-Impressionist show. After the Great War he concentrated on landscape painting, but preferred to work in France: 'I really think it's absurd to stay in England when there are such places on the same planet.'

p. 10 Woodcut from Roger Fry, *Twelve Original Woodcuts* (London, 1922), 5¾ × 4 (14.6 × 10.2). British Library, London.

GERE, Charles 1869–1957
Gere trained at the Birmingham School of Art which was a centre for the Arts and Crafts Movement and the Tempera Revival. In 1904 he settled at Painswick, in the hills between Stroud and Gloucester, and many of his paintings are of that area. He was interested in the art of Calvert and Palmer and tried to catch something of their spirit in his small-scale tempera paintings.

93 *British Camp, Malvern*, 9½ × 14¾ (24.3 × 37.6). By courtesy of Birmingham Museums and Art Gallery.

GILLIES, William G. 1898–1973
Between 1919 and 1922 Gillies studied at Edinburgh College of Art, and then in Paris. He was one of the most prolific of Scottish landscapists, painting on the Borders, in the Fife coastal villages, in Perthshire and on the Moray and Solway coasts. In 1939 he moved to the village of Temple in the Esk valley in Midlothian. 'I have always enjoyed weather, always seen landscape pictorially; and I've got immense pleasure from recording swiftly in drawings and water colours the fugitive, the subtle and the grand.' For further details, see T. Elder Dickson, *W. G. Gillies* (Edinburgh, 1974).

103 *Esperston*, 14 × 26 (35.6 × 66). The Tate Gallery, London.

GINNER, Charles 1878–1952

Ginner was born at Cannes of Anglo-Scottish parents, and between 1899 and 1904 worked in an architect's office in Paris. He studied painting in Paris and in 1908 exhibited at the Allied Artists Association exhibition in the Albert Hall. He thus came to know the Fitzroy Street group of artists around Sickert and Spencer Gore. In 1911 he was a founder member of the Camden Town Group. In an exhibition foreword in 1914 he wrote that his Neo-Realism 'must interpret that which, to us who are of this earth, ought to lie nearest to our hearts, i.e. life in all its aspects, moods and developments.' His rigorously controlled style recalls eighteenth-century pen drawing.

34 *The Window*, 33 × 21 (83.8 × 53.3). The Arts Council of Great Britain, London.

36 *Back Garden, Frimpton-on-Sea*, 7¼ × 8¼ (18.5 × 21). The British Council, London.

GRANT, Duncan 1885–1978

Duncan Grant's early years were spent in India, where his father's regiment was serving. It was his aunt, Lady Strachey (mother of Lytton Strachey), who persuaded his parents to allow him to attend the Westminster School of Art. After a year in Paris, he attended the Slade School of Fine Art for half a term before taking a studio in Fitzroy Square. He was introduced to the Bloomsbury circle by Lytton Strachey. In 1910 he was much impressed by Roger Fry's exhibition *Manet and the Post-Impressionists*, which led him to experiment for a while with abstraction. In 1911 he collaborated in the decoration of a room at the Borough Polytechnic, and from 1913 was involved with Roger Fry's Omega workshops. In 1915 he began to associate with the painter Vanessa Bell and in 1916 they moved to Charleston in Sussex. During the Great War he was a conscientious objector and worked on farms in Suffolk and in Sussex. His painting in the 1920s was more representational than his earlier work, but still remarkable for its rhythm and order; Raymond Mortimer described him as 'a painter who could make a tune out of a stove-pipe or a towel horse.' During the late 1920s and early 1930s he and Vanessa Bell made lengthy visits to Cassis where they rented a small farm building. In 1935 he painted three large decorative panels for the S.S. *Queen Mary*, but they were turned down by the chairman of Cunard and ended in the canteen of the National Gallery. Most of his English landscapes are of the Lewes area, near Charleston. During the Second World War he and Vanessa Bell painted religious subjects in the parish church of Berwick in Sussex – in anticipation of the day when all English stained glass would be destroyed by bombing. For a lively survey, see Raymond Mortimer's *Duncan Grant* (London, 1944).

19 *The Doorway*, 34⅝ × 30½ (88 × 77.5). The Arts Council of Great Britain, London.

53 *The Farm Pond near Firle, Sussex*, 31⅜ × 51½ (76.7 × 130.8). Art Gallery of Ontario, Toronto.

80 *Lewes Landscape*, 23¼ × 22½ (59 × 57.2). Leicestershire Museums and Art Galleries.

GRIGGS, Frederick Landseer Maur 1876–1958

Griggs was born at Hitchin in Hertfordshire and remained there until he was twenty-eight. Interested in art from an early age, he began to experiment with etching, inspired by the engravings of Samuel Palmer. After making perspective drawings for local architects, he illustrated the first of his thirteen 'Highways and Byways' guide books for Macmillan. In 1903 he moved to Chipping Campden in the Cotswolds where there was a flourishing Guild of Handicrafts. In 1912 he began to etch seriously. He was an enthusiast for the preservation of old England, and one of the most influential graphic artists of the 1920s.

11 *The Porch of the Church of St Giles, Stoke Poges*, 3¾ × 4⅝ (9.5 × 11.1). Victoria and Albert Museum, London.

GWYNNE-JONES, Allan 1892–1982

Gwynne-Jones's father was a solicitor and his mother translated poetry from French and German. Between 1912 and 1914 he lived in Cheyne Walk in London where he became friends with the painter Randolph Schwabe and with Augustus John, J. D. Innes and Albert Rutherston. After the war he went to the Slade, and by 1923 had become Professor of Painting at the Royal College of Art, then under reform by William Rothenstein; his students there included Evelyn Dunbar and Barnett Freedman, and Percy Horton was one of his colleagues. In 1930 he returned to the Slade as a member of the staff. Most of his landscape painting dates from before the Second World War. During his later years he concentrated on flower paintings and on portraits. Some small pictures he had made in Cornwall in 1919 before returning to the Slade formed the basis of the painting of *Poltesco Farm*. Froxfield, the subject of his etching, is a hamlet near Petersfield in Hampshire. His work is surveyed by David Brown in an exhibition catalogue, *Allan Gwynne-Jones* (National Museum of Wales, Cardiff, 1982).

1 *Spring Evening, Froxfield*, 5⅞ × 7½ (15 × 19). Courtesy Rosemary Gwynne-Jones.

10 *Poltesco Farm, Ruan Minor, Cornwall*, 39 × 45 (99 × 114.3). Private Collection.

HASSALL, Joan b.1906

The daughter of John Hassall the advertising artist, Joan Hassall studied at the Roehampton Froebel Training College from 1922 to 1925, and then at the London School of Art, before attending the Royal Academy Schools from 1928 to 1933. She also took evening classes in photo-

engraving at Bolt Court, Fleet Street, from 1931 to 1934. Her work as a wood engraver and book illustrator is very much in the style of Thomas Bewick. Her career is outlined in B. Peppin and L. Micklethwait's *Dictionary of British Book Illustrators: The Twentieth Century* (London, 1983).

123 *The Stricken Oak*. Frontispiece to Frances Brett Young, *Portrait of a Village* (London, 1937). 6 × 4¼ (15.2 × 10.8). Victoria and Albert Museum, London.

HENNELL, Thomas Barclay 1903–45

Hennell was brought up in his father's rectory at Ridley in Kent – not far from Samuel Palmer's 'Valley of Vision' at Shoreham. He was trained at the Regent Street Polytechnic in London from 1921 to 1925. He knew the Bawden and Ravilious families at Bardfield in Essex, and visited them from 1931 onwards when he was preparing his book *Change on the Farm* (London, 1934). After a mental illness in the early 1930s, he returned to painting in 1936 and moved back to Ridley. His experience of mental breakdown is described in *The Witnesses* (London, 1938). In addition to being an expert on farm practices he was a poet of distinction and an illustrator – mainly of books by the country writer H. J. Massingham. He worked for the Pilgrim Trust/Oxford University Press project *Recording Britain* in 1940 and was commissioned as a war artist in 1941, seeing service on the Home Front, off Iceland, in Normandy, in India, Burma and the East Indies, where he was killed in November 1945 by Indonesian nationalists. His knowledge of the British countryside was exceptional: 'all the country's history, and not only a chronicle of small-beer, is written out in the carpentry of broken carts and waggons, on the knots and joints of old orchard-trees, among the tattered ribs of decaying barns, and in the buried ancestral furrows and courses which can still be traced under the turf when the sun falls slantwise across the fields in long autumn afternoons.' (From the preface to *Change on the Farm*.) His career is outlined by Michael MacLeod in the exhibition catalogue *Hartrick/Hennell/Lines* (London, 1980).

112 *Landscape near Ridley, Kent*, 12¼ × 18⅞ (31 × 48). Private Collection.

HEPPLE, Robert Norman b.1908

Hepple studied at Goldsmiths' School of Art and at the Royal Academy Schools. During the 1930s he was an active illustrator, especially of the novels of the Shropshire writer Mary Webb. After serving as an official war artist he made a considerable reputation as a portraitist and subject painter.

p. 9 Illustration from Mary Webb, *The House in Dormer Forest* (London, 1931).

p. 13 Illustration from Mary Webb, *The Golden Arrow* (London, 1930).

HERMAN, Josef b.1911

The son of a Jewish shoemaker, Josef Herman was born and trained in Warsaw. In 1938 he left Poland for Brussels, where he met the Belgian painter Constant Permeke. He moved to Glasgow in 1940, and thence to the mining village of Ystradgynlais in South Wales in 1944, where he remained for eleven years. He described his painting in Wales: 'looking at the landscape, . . . talking to miners on the surface and underground, at work and at rest, studying their movements and their appearance . . . a way of getting myself through the thick cloud of insignificant incidents in which is enclosed before us every new reality.'

129 *Autumn*, $19\frac{3}{4} \times 24\frac{3}{4}$ (50.2 × 62.8). The Roland Collection.

HERMES, Gertrude 1901–83

Between 1921 and 1925 Gertrude Hermes studied at Leon Underwood's School of Painting and Drawing in London, and in 1922 made her first wood engraving. In 1926 she married the wood engraver Blair Hughes-Stanton and with him worked on engravings for *The Pilgrim's Progress* (London, 1928). Working for the Gregynog Press, she moved to Gregynog in Wales in 1928, and thence to Hatcheson in Suffolk in 1929. Between 1934 and 1936 she visited Scotland and the Outer Hebrides, which confirmed her association with the sea and with wild coastlines. Her art is surveyed in the exhibition catalogue *Gertrude Hermes* (Whitechapel Art Gallery, London, 1967).

6 *Willows and Waterlilies*, $11\frac{1}{2} \times 7\frac{5}{8}$ (29.2 × 19.4). Victoria and Albert Museum, London.

120 *Through the Windscreen*, 5 × 7 (12.7 × 17.8). Towner Art Gallery, Eastbourne.

HILDER, Rowland b.1905

Hilder was born at Great Neck, Long Island, USA, but in 1915 came with his family to London. At the age of sixteen he entered Goldsmiths' School of Art to study etching under Alfred Bentley and Malcolm Osborne, and drawing under Edmund Sullivan. Early influences included Muirhead Bone and Frank Brangwyn, the latter recommended to him by Graham Sutherland, a fellow student. He hoped to follow the example of W. L. Wyllie and to become a marine painter. By 1925 he had begun to illustrate books for the publishers Blackie and Cape. Between 1925 and 1935 he illustrated nine books by Percy Westerman, as well as Mary Webb's *Precious Bane*, one of her Shropshire novels. In 1929 he began to work for Jack Beddington at Shell-Mex. He also designed Christmas cards and book tokens, and drew for *The Sphere*. In 1935 he moved to Blackheath, by which time he was becoming well known for his drawings and paintings of Kentish landscape. After designing National Savings posters, he

served in 1941 as a camouflage officer and illustrated the *Army Manual on Camouflage*. In 1945 he painted pictures for Whitbread's advertising. In 1955 he worked with his wife Edith and with Geoffrey Grigson on *The Shell Guide to Flowers of the Countryside*. His painting for *The Shell Guide to Kent* of 1958 was the first of the county guide pictures. The only survey of his life and work is John Lewis's *Rowland Hilder: Painter and Illustrator* (London, 1978).

50 *The Garden of England*, $19\frac{1}{2} \times 29\frac{1}{2}$ (49.5 × 74.9). Courtesy Rowland Hilder.

HILLIER, Tristram 1905–83

Hillier was born in Peking. He studied economics for two years at Cambridge, but left when his father died, and went to work in an accountant's office before entering the Slade School of Fine Art in 1926. He also studied with Bernard Meninsky at the Westminster School of Art. In 1927 he went to Cassis, near Marseilles, where he met Clive and Vanessa Bell, Duncan Grant and the Penroses. This period in his life, through the 1930s and into the Second World War, is described in his autobiography *Leda and the Goose* (London, 1954). In 1933, after the breakdown of his marriage, Hillier stayed with the painter Richard Wyndham at Tickerage Mill in Sussex: 'Good food and wine ranked only less important in his interests than the Arts, and as in both spheres he showed fine judgement, his house had become a meeting place for many of the most stimulating characters of the time.' In the 1920s he painted decoratively in the style of Duncan Grant; in the late 1920s and 1930s he was influenced by De Chirico and the Surrealists. In 1933 he was a member of Unit One, and his paintings of that time are both modernist and desolate, their pylons at once tokens of a new age and an offence against nature. The *Beach Scene* illustrated here has the name Clough Ellis pencilled into the margin; Clough Williams-Ellis edited *Britain and the Beast* (London, 1937), essays on the despoliation of the British countryside. During the war Hillier served in the RNVR and in 1943 started to paint again in Somerset. An account of his life by Nicholas Usherwood appears in the exhibition catalogue *A Timeless Journey: Tristram Hillier, R.A. 1905–1983* (Royal Academy, London, 1983).

87 *Beach Scene with Radio Masts*, $11\frac{3}{4} \times 15\frac{1}{2}$ (30 × 39.5). Private Collection.

HITCHENS, Ivon 1893–1979

Hitchens only began to paint seriously in about 1933, although he had trained at the St John's Wood School of Art and at the Royal Academy. Friendly with Ben Nicholson, he exhibited with the 7 & 5 Society, but after painting lyrical, naive landscapes he turned towards abstraction in 1934. Most of his work is evidently based on landscape, painted with broad swinging rhythms and simplified to the point of abstraction. In 1940

he bought a caravan and, with his wife and child, moved into a thicket on Lavington Common, near Petworth in Sussex, and, amongst rhododendrons, silver birch, oaks and bracken, painted through the war. His life and work is surveyed by Alan Bowness in *Ivon Hitchens* (London, 1973).

31 *Winter Stage*, $23\frac{1}{4} \times 61\frac{1}{4}$ (59 × 155). The Tate Gallery, London.

HODGKINS, Frances 1870–1947

A New Zealander, Frances Hodgkins moved to Europe at the age of thirty, and spent her first summer with a watercolour class in Brittany. She travelled to Morocco, and to Holland where she studied the work of Maris and Mauve. She was the first woman to teach at the Académie Colarossi in Paris. In 1915 she moved from Paris to St Ives and, inspired by Cedric Morris and Lett Haines, began to paint in oils in 1919. She moved around in England and stayed for short periods in the Cotswolds and East Anglia. She also worked a good deal in France. In 1936 in *Bali and Angkor* the influential anthropologist Geoffrey Gorer recommended her as one of the most interesting artists in England: 'Her vision embraces practically all the non-human side of nature; she paints common household objects and landscapes . . . in such a way that the least interesting objects and views obtain an unsuspected significance and beauty.'

16 *Still-life*, $14\frac{7}{8} \times 17\frac{1}{2}$ (37.8 × 44.5). The Tate Gallery, London.

HORTON, Percy 1897–1970

Percy Horton was the eldest son of a bus conductor. Between 1912 and 1916 he attended Brighton School of Art. In 1916, on conscription, he refused to serve in the armed forces and even refused alternative service, which led to his imprisonment for two years in Calton Prison in Edinburgh. Between 1919 and 1920 he studied at the Central School of Arts and Crafts in London. Here he was taught outline drawing from the model by A. S. Hartrick, and this was a lasting influence. Between 1922 and 1924 he was a student at the Royal College of Art, then undergoing reform at the hands of William Rothenstein. Thereafter he taught drawing at the Nonconformist Bishop's Stortford College, before joining the teaching staff of the Royal College in 1930, where he taught for the next nineteen years. During the 1930s he also taught at the Working Men's College at St Pancras, where his colleagues were Geoffrey Rhoades and Barnett Freedman. He agitated for a social consciousness among artists and disliked unsophisticated painting in the early 1930s at a time when Christopher Wood was popular. During the Second World War he moved to Ambleside with the Royal College of Art. From 1949 until 1964 he was drawing master at the Ruskin School in Oxford. Figure drawing was his main interest,

but he painted many landscapes in Kent, Sussex and the Lake District, often paying special attention to building and stonework. His career is surveyed by Janet Barnes in an exhibition catalogue, *Percy Horton: Artist and Absolutist, 1897–1970* (Sheffield City Art Galleries, 1982).

24 *Kensington Gardens*, 25 × 40 (63.5 × 101.6). Private Collection.

67 *Barn and Oast Houses at Marden, Kent*, 10 × 14 (25.4 × 35.6). Private Collection.

HYDE, Joan fl. 1930–40

Joan Hyde exhibited in the 1930s at the Redfern Gallery in London with the Society of Wood-Engravers.

60 *Cobbett's Rural Rides*, 5½ × 4½ (14 × 11.4). Victoria and Albert Musuem, London.

JONES, David 1895–1974

David Jones's father was a printer's overseer from Holywell in Flintshire, and his mother the daughter of a mast-and-block maker of Rotherhithe. He attended Camberwell School of Arts and Crafts before serving with the Royal Welsh Fusiliers in the Great War. He then studied at the Westminster School of Art under Walter Bayes and Bernard Meninsky. In 1921 he became a Roman Catholic and joined Eric Gill's Ditchling community where he learned wood engraving. In 1923 he was admitted as a Tertiary of the Order of St Dominic and in 1924 moved with Gill to Capel-y-ffin in the valley of Honddu, north of Abergavenny. He became engaged to Gill's daughter Petra, but the engagement was broken off and Jones never married. He painted landscapes at Capel and on Caldy Island as well as at Portslade near Brighton. He joined the Society of Wood-Engravers in 1927, and illustrated books for The Golden Cockerel Press from 1925 onwards. In 1928 he joined the 7 & 5 Society, with which he exhibited until 1933. He began to write his epic poem on the Great War, *In Parenthesis*, after a trip to France in 1928 when he visited the countryside associated with *Le chanson de Roland*. In 1935 he wrote a note on his years as a landscape artist: 'I always work from the window of a house if it is at all possible. I like looking out on the world from a reasonably sheltered position. I can't paint in the wind, and I like the indoors-outdoors, contained yet limitless feeling of windows and doors. A man should be in a house; a beast should be in a field, and all that. The rambling, familiar, south, walled, small, flower-beddedness of Pigotts and the space, park, north, serene, clear, silverness of Rock in Northumberland both did something.' Pigotts was a farmhouse surrounded by woods north of High Wycombe in Buckinghamshire, to which Eric Gill moved in 1928. Rock Hall was the Northumberland home of the collector Helen Sutherland, whom Jones visited regularly from 1929 onwards. In 1932 he suffered a breakdown

and from then on he periodically endured ill health. Paul Hills surveys his career in detail in the exhibition catalogue *David Jones* (Tate Gallery, London, 1981).

2 *Brockley Gardens*, 25 × 19¼ (63.5 × 49). Reproduced by permission of the Trustees of the David Jones Estate. Photo courtesy of Sotheby's, London.

25 *The Garden Enclosed*, 14 × 11¾ (35.6 × 29.8). The Tate Gallery, London.

32 *The Chapel in the Park*, 24½ × 19¾ (62.2 × 50.2). The Tate Gallery, London.

JONES, Fred Cecil 1891–1956

Jones was born in Bradford and between 1905 and 1916 attended Bradford College of Art. From 1930 to 1935 he was a part-time student at Leeds School of Art. He and his wife became art teachers at Pudsey Technical and Grammar School, near Leeds.

41 *Chimney Stacks and Winding Ways, Whitby*, 19½ × 16½ (49.5 × 41.9). The Tate Gallery, London.

JONES, Harold b. 1904

Born at Romford in Essex, Jones worked on a farm before attending Goldsmiths' School of Art in 1921. He studied drawing, design and engraving at the Royal College of Art between 1924 and 1928. In the late 1930s he taught in Bermondsey and then at the Ruskin School of Drawing in Oxford. He became active as a book illustrator around 1937, when he illustrated Walter de la Mare's *This Year: Next Year*, whose dust jacket features another version of the open door and landscape illustrated here.

18 *The Black Door*, 19½ × 13¼ (49.5 × 33.6). The Tate Gallery, London.

KAUFFER, Edward McKnight 1890–1954

McKnight Kauffer was born in Montana, USA, and studied art in San Francisco, Chicago, Munich and Paris before moving to London in 1914. For twenty-five years he was the main designer of London Underground posters. In 1921 he gave up painting entirely for commercial art. He worked for the London Transport Board, Shell-Mex and BP, the Great Western Railway, the Empire Marketing Board, the Orient Line, the Post Office, and the Gas, Light and Coke Company. He also did many book illustrations in the 1920s, mainly printed at the Curwen Press. He was quite outstanding as a poster designer, and was considered by his contemporaries to be a miracle worker in sales terms.

55 *Spring on the Hillside*. Poster advertising London Transport, 40 × 25 (101.6 × 63.5). London Transport Executive.

77 *Flowers of the Hills*, 40 × 25 (101.6 × 63.5). London Transport Executive.

KNIGHT, Charles b. 1901

Knight trained at Brighton School of Art and then at the Royal Academy Schools in the early 1920s, where he was instructed by Charles Sims and W. R. Sickert. He learned Sims's technique of painting in oil over a tempera base, while Sickert taught him to look at life. Subsequently he returned to Brighton as a teacher, and taught there until his retirement. He made forty drawings for the Pilgrim Trust/Oxford University Press project *Recording Britain* in 1940. He also painted railway carriage panels of Lancashire scenes for which he was paid transport costs only. His landscape style was influenced by Cotman, and also by Titian, whom he studied in the National Gallery. The painting illustrated here of Ditchling Beacon (near the artist's home) was first published by the Medici Society as a print in 1950.

122 *Ditchling Beacon*, 27½ × 35½ (70 × 90.2). Towner Art Gallery, Eastbourne.

KNIGHT, Harold 1874–1961

Harold Knight studied at Nottingham School of Art, at the Royal Academy and in Paris. He painted at Staithes on the Yorkshire coast and worked in Holland and at Newlyn in Cornwall. In 1903 he married Laura Johnson. He was noted for his portraits and his quietist paintings of interiors.

102 *Whitesands Bay, Cornwall*, 25 × 30 (63.5 × 76.2). The Fine Art Society, London.

KNIGHT, Dame Laura 1877–1970

Laura Knight's mother taught drawing in Nottingham, and when she fell ill, Laura (née Johnson) took over her teaching jobs at the age of fourteen. She studied at Nottingham School of Art, where she met the painter Harold Knight, whom she married in 1903. Between 1904 and 1907 she spent much time in Holland, and on her return moved to Newlyn in Cornwall, where she and her husband shared a house with Alfred Munnings. In 1913 they moved to Lamorna, also in Cornwall, and then to London in 1918. She became increasingly interested in the backstage life of the ballet and the circus, but continued to paint at Lamorna during the summer. She was also a prolific etcher. Her life story is told in *The Magic of a Line* (London, 1965).

100 *Sennen Cove, Cornwall*, 24 × 30 (61 × 76). Private Collection. Photo courtesy of Sotheby's, London.

106 *September Radiance*. Poster advertising London Transport, 40 × 25 (101.6 × 63.5). London Transport Executive.

LAMB, Lynton 1907–77

Between 1927 and 1930 Lamb studied at the Central School of Arts and Crafts in London, and then joined the Oxford University Press. He began to illustrate in 1929, and in 1939 did wood

engravings for Flora Thompson's *Lark Rise to Candleford*. The idea for *County Town* came to him while he was in the army: 'The war-time soldier is passed through the community like some bacillus in a sealed tube. Provided that he does not try to issue from his bung, he can enjoy a detachment of observation seldom possible to the civilian.' For a full account of his career, see George Mackie, *Lynton Lamb: Illustrator* (London, 1978).

p. 15 *The Viaduct.* Woodcut from Lynton Lamb, *County Town* (London, 1950).

LARKINS, William 1901–74

Larkins was born into a family of steeplejacks in Bow, London. He spent five years at Goldsmiths' School of Art in South London and became a skilled etcher under the supervision of Frederick Marriott, Alfred Bentley and Malcolm Osborne. His teachers included the painter Clive Gardiner and the illustrator E. J. Sullivan. Alfred Drury introduced him to Frank Brangwyn who was impressed by his Welsh and Belgian etchings of 1922–23. He was elected a member of the Print Society in 1922. His etchings of the late 1920s are rich in expressive shadow and atmosphere. In 1932 he joined the advertising agency J. Walter Thompson as an art director. Here he designed the Black Magic chocolate box, a streamlined modern design which remained in use for thirty-five years. In 1949 he joined *Reader's Digest* to direct their art and graphics. Graham Sutherland said of him: 'I think it is true to say that he was the first person to alert us to the excellence of the etchings of Samuel Palmer, a print by whom he bought in Charing Cross Road. This must have been around 1924 or 1925.' (Quoted in Gordon Cooke, *William Larkins: Etchings of the East End in the 1920s and Other Scenes*, London, 1979.)

5 *Troutwater*, $6\frac{3}{8} \times 9\frac{7}{8}$ (16.2 × 25). Garton and Cooke, London.

LEIGHTON, Clare b.1901

Clare Leighton studied at Brighton School of Art, at the Slade School of Fine Art and at the Central School of Arts and Crafts where she learned wood engraving under Noel Rooke. She quickly became a noted wood engraver, specializing in rural subjects. *The Farmer's Year* of 1933 features some of her labourers, heroic in the German or Russian style. In *Four Hedges* of 1935, also written and engraved by herself, gardening is shown in equally vehement terms. Her emphatic close-ups of garden items recall the German New Objectivity from the 1920s and the contemporary work of the wood engraver Agnes Miller-Parker. In 1939 she settled in America.

p. 6 *April.* Illustration from Clare Leighton, *The Farmer's Year* (London, 1933).

73 *February.* Illustration from Clare Leighton, *The Farmer's Year* (London, 1933).

LOWRY, Laurence Stephen 1887–1976

Lowry was born in Old Trafford, Manchester. He took private painting lessons with William Fitz before working as a clerk with a firm of chartered accountants in 1904. He studied at the Municipal College of Art in Manchester between 1905 and 1915. In 1909 he moved to Pendlebury, near Salford: 'I started painting Salford by accident. I was at Manchester School of Art – and I wasn't doing very well, I can tell you. One day I missed the train to school, and I had a bit to wait so I walked up and down outside the station. There was a spinning mill, and so I got a pad and started drawing it – and then, when I'd done a few more drawings, I painted the mill. And that's how it all started.'

He travelled, but never outside England: 'I've been coming to London once a month for over 61 years.' In 1939 his mother died: 'She stood by me for 24 years because she had faith in me. I nursed her for 14 years and the last nine of her life she had to stay in her bed. I looked after her and painted – that's all I had time for.' In 1948 he moved to Mottram-in-Longdendale in Cheshire. Celebrity caught up with him and he became an ARA in 1955 and an RA in 1961. He spoke of his work to Edwin Mullins in the mid 1960s: 'Had I not been lonely none of my work would have happened. I should not have done what I've done, or seen the way I saw things. I work because there's nothing else to do.' He interviews well in Noel Barber's *Conversations with Painters* (London, 1964).

83 *Lake Landscape*, 28 × 36 (71.1 × 91.5). Whitworth Art Gallery, University of Manchester. Reproduced by permission of the copyright owner, Mrs Carol Ann Danes.

MACKINTOSH, Charles Rennie 1868–1928

Mackintosh was born in Glasgow, where in 1884 he was apprenticed to an architect. With Herbert MacNair and Margaret and Frances MacDonald he developed the 'Glasgow Style' of Art Nouveau. In 1896 he designed the new Glasgow School of Art, which was to be one of his most famous buildings. After more than twenty years as an architect in a modern style he became discouraged, and after the Great War designed textiles and painted landscape watercolours. On leaving Glasgow in 1914 he moved to Walberswick in Suffolk, before settling in Chelsea in 1916. The painting of Worth Matravers in Dorset features the ancient terracing system of strip lynchets for which that valley is especially well known. A full account of his career is given by Thomas Howarth in *Charles Rennie Mackintosh and the Modern Movement* (London, 1952).

8 *The Downs, Worth Matravers*, $17\frac{3}{4} \times 21\frac{1}{8}$ (45.2 × 53.7). The Glasgow School of Art.

MAHONEY, Charles 1903–68

Born in Lambeth, Charles Mahoney was trained in commercial art before attending the Royal College of Art between 1922 and 1926, where he also taught between 1928 and 1953. Between 1941 and 1952 he worked on a series of paintings for the Lady Chapel at Campion Hall, the Jesuit College in Oxford. He was a very keen gardener and in 1937 wrote and illustrated *Gardeners' Choice* with Evelyn Dunbar. For an appreciative memoir, see Sir John Rothenstein in the catalogue *Charles Mahoney* (The Parkin Gallery, London, 1975).

59 Study for *Adam and Eve in the Garden of Eden*, $15\frac{7}{8} \times 10\frac{5}{8}$ (40.3 × 27.6). The Tate Gallery, London.

MARTIN, Ellis

Martin worked as Chief Designer for the Ordnance Survey during the early years of the century.

49 Illustration for the Ordnance Survey map of Land's End and the Lizard. Ordnance Survey.

McKENZIE, Alison 1907–82

After attending the Glasgow School of Art between 1926 and 1929, Alison McKenzie studied wood engraving with Iain McNab at the Grosvenor School of Art. From 1942 she lived at St Andrews and worked as a part-time teacher at Dundee College of Art. She designed posters for LNER and London Transport.

39 *The Cod and Lobster Inn, Staithes*, $7\frac{3}{4} \times 9$ (19.6 × 23). Blond Fine Art, London.

MENINSKY, Bernard 1891–1950

Meninsky was born in the Ukraine, but was brought to Liverpool at a very early age. In 1906 he entered the Liverpool School of Art and in 1912 went to the Slade School of Fine Art. In 1919 he was elected a member of the London Group and in 1920 succeeded Sickert as teacher of life drawing at the evening classes of the Westminster School of Art. His work was influenced at first by Masaccio, Cézanne and Derain and then by Picasso's Neo-Classicism. From 1940 he taught at the City of Oxford Art School and became friendly with Paul and Margaret Nash. Although best known for his figure drawings, he had painted landscapes at Fordingbridge in the 1920s. He was especially interested in Blake's woodcuts and at the end of an essay on drawing in 1948 quoted Sir Thomas Browne: 'There is something in us that was before the elements and owes no homage unto the sun.' His late landscapes are comparable in their grandeur to those of Paul Nash.

135 *The Journey*, 25 × 30 (63.5 × 76.2). Blond Fine Art, London.

MILLER-PARKER, Agnes 1895–1980

Agnes Miller-Parker was the daughter of an analytical chemist. She studied at the Glasgow School of Art from 1914 to 1919. In 1918 she married William MacCance, a typographer and

sculptor, with whom in 1931 she worked on Caxton's *The Fables of Aesop* (Gregynog Press). Inspired by Northern Renaissance art, she taught herself wood engraving in 1926. She worked mainly for the Gregynog and Golden Cockerel Presses, specializing in landscape and in rural subjects. She contributed seventy-three engravings to H. E. Bates's *Through the Woods* in 1936 and another eighty-three to his *Down the River* in 1937. She tended to make the landscape and its details strange and pungent, in the style of the German New Objectivity. While Bates attended scrupulously to the changing seasons and ferociously to gamekeepers and hunters, she depicted a countryside furnished with anthropomorphic toadstools, catkins and twigs, leathery chestnut leaves and sculpted pine cones – a whole cabinet of curiosities. Her work is surveyed by Ian Rogerson in *Agnes Miller-Parker* (Manchester, 1983).

p. 11 Wood engraving from A. E. Housman, *A Shropshire Lad* (London, 1940).

MINTON, John 1917–57
John Minton was born in Cambridge, and between 1935 and 1938 he studied at the St John's Wood Art School. In 1938 he went to Paris, where he shared a studio with Michael Ayrton and Michael Middleton. Although a painter, John Minton is best known for his book illustration. He worked for such periodicals as *The Radio Times*, *The London Magazine*, *Vogue* and *Chemical Age*, and began book illustration in 1947 with Alain Fournier's *The Wanderer* (*Le Grand Meaulnes*). He drew in the Kent and Surrey countryside in 1943 and in Cornwall in 1945. His illustrations appear in *A Book of Mediterranean Food* (London, 1950) and in *French Country Cooking* (London, 1951), both by Elizabeth David.

p. 8 *The Great Snow*. Illustration from H. E. Bates, *The Country Heart* (London, 1949).

37 *Cornish Village*, 10⅞ × 14¾ (27.5 × 37.5). Hove Museum and Art Gallery.

MORGAN, Gwenda b.1908
Gwenda Morgan studied at Goldsmiths' School of Art and then at the Grosvenor School of Art under the illustrator Iain MacNab. She exhibited with the Society of Wood-Engravers and worked as a book illustrator; see, for instance, her wood engravings for Thomas Gray's *Elegy Written in a Country Churchyard* (London, 1946).

13 *The Walnut Tree*, 7 × 7 (17.8 × 17.8). Blond Fine Art, London.

MORRIS, Sir Cedric 1889–1981
In 1914 Morris studied at the Académie Delacluse in Paris, and joined The Artists' Rifles at the outbreak of the Great War. In 1917 he painted in Cornwall and in 1918 met his lifelong companion, the artist Lett Haines. He moved to Paris in 1921

and studied at the Académie Moderne under Othon Friesz, André Lhote and Fernand Léger. Basically a town hater, he worked often in the South of France and in Brittany. Christopher Wood was very much influenced by his painting. From 1936 he and Lett Haines ran the East Anglian School of Painting at Dedham, and in the late 1930s he taught painting at the Dowlais Settlement in Wales. He was also well known as an authority on the propagation of irises. His art is comprehensively surveyed by Richard Morphet in the exhibition catalogue *Sir Cedric Morris* (Tate Gallery, London, 1984).

7 *South Pembrokeshire Landscape*, 24 × 28 (61 × 71). Blond Fine Art, London.

22 *The Red Pond*, 24 × 28 (61 × 71). Blond Fine Art, London.

58 *Stoke-by-Nayland*, 23½ × 32 (59.7 × 81.3). National Museum of Wales, Cardiff.

MUNNINGS, Sir Alfred 1878–1959
Munnings was born at Mendham in Suffolk and spent his early youth in the East Anglian countryside. He trained as a lithographer in Norwich, during which time he lost the sight of one eye. He studied at the Norwich School of Art and at the Académie Julian in Paris. Initially, he painted landscapes and scenes from rural life, with fairs, gipsies, cattle, ponies and donkeys. He moved to Zennor on the north coast of Cornwall, not far from St Ives, and concentrated on pictures of horses in landscapes and on such genre scenes as gipsy hop-pickers at work in Hampshire. The commercial success of his paintings allowed him to buy Castle House at Dedham in Suffolk. It was only in 1919 that he began the equestrian portraiture for which he became famous. He became President of the Royal Academy in 1944 and wrote a lively three-volumed autobiography.

46 *From My Bedroom Window*, 36 × 40 (91.4 × 101.6). The Tate Gallery, London.

NASH, John Northcote 1893–1977
On the advice of his brother Paul, John Nash had no formal art education. Having taken up oil painting in 1914, he became an official war artist in 1918. He began wood engraving in 1921, and between 1924 and 1929 taught at the Ruskin School of Drawing in Oxford, and then at the Royal College of Art from 1934. From 1919 he made humorous drawings for the periodical *Far and Wide*. As a book illustrator he specialized in rural subjects, and had a strong feeling for nature. He illustrated Adrian Bell's *Men and the Fields* (London, 1939), described by Ronald Blythe as 'a vivid evocation of the area dividing the Gainsborough from the Constable country as it was just before the second agricultural revolution.' In a memorial exhibition, *John Nash R.A.* (The Minories, Colchester, 1979), Ronald Blythe described his art: 'His way was to define or alight

on two rather straightforward actualities, those of nature and its agricultural or industrial disturbance, and to abstract their patterns.'

p. 14 *September*. Illustration from John Pudney, *Almanack of Hope* (London, 1944).

62 Lithograph from Adrian Bell, *Men and the Fields* (London, 1939).

NASH, Paul 1889–1946
Nash was born in London but in 1901 his family moved to Iver Heath in Buckinghamshire. After 'the long and complicated purgatory of school life' he enrolled on an illustration course at Chelsea Polytechnic. In 1908 he moved to a London County Council school of illustration at 6 Bolt Court, Fleet Street, and thence to the Slade School of Fine Art in 1910. He was deeply impressed in his youth by the poetry of W. B. Yeats and the art of D. G. Rossetti, but had 'a rather striving barren time at the Slade.' He began to be interested in landscape painting from about 1911, under the influence of Sir William Nicholson and of his Slade contemporary Claughton Pellew-Harvey. He enlisted in 1914 and was sent to the Ypres Salient in 1917. Later that year he was appointed an official war artist. His letters speak of 'those wastes in Flanders, the torments, the cruelty & terror of this war.' In the early 1920s he was influenced by Derain: 'I do tenderly hope you weren't much Derainged in Paris', wrote the poet Gordon Bottomley to Nash in May 1925. From 1921 to 1925 he lived at Dymchurch in Kent. In 1924 he began to sell paintings and to travel abroad, and also visited Ben and Winifred Nicholson in Cumberland. The following year he moved to Iden, near Rye. By 1928 he was a popular landscape painter, which worried him; after that he included more surreal and still-life elements in his work, influenced by De Chirico and by Russian theatre design. The years 1929 and 1930 were a period of crisis following the death of his father; he also began to develop asthma, which eventually became chronic. At around this time he started taking photographs, using them as a basis for painting. In 1931 he concentrated on designs for Sir Thomas Browne's *Urne Buriall and The Gardens of Cyrus* (London, 1932). Impressed and influenced initially by the Avebury megaliths in 1933, he became fascinated by standing stones and earthworks after his move to Swanage in Dorset in 1934. This led to a renewed interest in landscape art, which was to last until his death: 'I am beginning now to find my way between the claims of "Abstractions" and pure interpretations. As you know, I am far too interested in the character of landscape and natural forms generally – from a pictorial point of view – ever to abandon painting *after* Nature of some kind or other. But I want a wider aspect, a different angle of vision.' (From a letter to Anthony Bertram, 1934.) From 1937 he worked on the *Shell Guide to Dorset*. At this time he

increasingly thought of himself as a poetic painter, and his late landscapes, with their suns and moons, earthworks, forests and fungi, are heavily symbolic. For an evocative account of his early life, see *Outline: An Autobiography and Other Writings* (London, 1949).

9 *Souldern Pond*, $28\frac{1}{4} \times 36\frac{1}{4}$ (71.7 × 92.1). Blond Fine Art, London.

15 *The Thatched Cottage*, 20 × 24 (50.8 × 61). Blond Fine Art, London.

65 *Landscape at Iden*, $27\frac{1}{2} \times 35\frac{3}{4}$ (69.8 × 90.8). The Tate Gallery, London.

82 Design for a dust jacket for Richard Aldington, *Roads to Glory* (London, 1930), 8 × 5 (20.3 × 12.7). Victoria and Albert Museum, London.

107 *Trees and Cottages, Cumberland*, $9\frac{3}{8} \times 12$ (23.7 × 30.6). Victoria and Albert Museum, London.

131 *Pillar and Moon*, 20 × 30 (50.8 × 76.2). The Tate Gallery, London.

132 *Landscape of the Vernal Equinox*, 28 × 36 (71.2 × 91.4). Reproduced by the gracious permission of Her Majesty Queen Elizabeth the Queen Mother.

NEWTON, Algernon 1880–1968
Born in Hampstead and brought up in Northamptonshire, Newton studied at Clare College, Cambridge, for one year before enrolling at the Frank Calderon School of Animal Painting around 1900. He had family connections with Cornwall and owned a house near Lamorna Cove, where he met the painters Lamorna Birch, Ethel Walker and Alfred Munnings. He was not a successful painter to begin with, and it was only in the 1920s that he found a subject and a style: townscapes in a style influenced by Canaletto. From around 1920 he began to paint architectural views of London: evening scenes, very precisely painted. Biographical details and memoirs appear in an essay by Nicholas Usherwood in the exhibition catalogue *Algernon Newton R.A. 1880–1968* (Sheffield City Art Galleries, 1980).

136 *The Derby 1920*, $21\frac{1}{2} \times 30\frac{1}{4}$ (54.6 × 76.8). The Fine Art Society, London.

NICHOLSON, Ben 1894–1982
Ben Nicholson was the eldest son of the painters Sir William Nicholson and Mabel Pryde. In 1910 and 1911 he attended the Slade School of Fine Art and came to know Paul Nash, also a student there. For the next six years he painted very little and spent most of his time abroad, for reasons of ill health. In 1920 he married the painter Winifred Roberts. Ivon Hitchens proposed him for membership of the 7 & 5 Society in 1923, an exhibiting organization set up in 1919. Nicholson became chairman of the Society by 1926, and

under his influence it became a powerful force in the promotion of naive, representational painting, including that of the Douanier Rousseau. He met Christopher Wood in 1926, and in the summer of 1928 while on a visit to St Ives they met the naive painter Alfred Wallis for the first time. Perhaps stimulated by Wallis, Nicholson abandoned traditional pictorial space in favour of more abstract arrangements of outlined and silhouetted forms. From 1930 onwards he became increasingly interested in modernist art in Paris. From 1931 to 1939 he worked at the Mall Studios in Hampstead, after which he moved to Cornwall, staying with Adrian Stokes at Carbis Bay until 1943, and then to St Ives. During these years his friends and neighbours included Piet Mondrian in London and Naum Gabo in Cornwall. While continuing to make abstract reliefs in Cornwall he resumed landscape painting and architectural drawing. In 1958 he moved to Ticino in Switzerland. A major source for his art is Charles Harrison's catalogue *Ben Nicholson* (Tate Gallery, London, 1969).

115 *Mousehole*, $18\frac{1}{4} \times 23$ (46.4 × 58.4). The British Council, London.

NICHOLSON, Winifred 1893–1981
Winifred Nicholson attended the Byam Shaw School of Art and studied in Paris, and in 1920 married Ben Nicholson. In 1925 she joined the 7 & 5 Society, with which she exhibited until 1935. She painted in Cumberland and in Cornwall during the 1920s and 1930s, in an unaffected style very close to that of Christopher Wood. In 1937 she wrote of painting as a mystical calling which gave access to the truth: 'Any true colour picture gives out light like a lamp.' Some of her highly poetic writing is quoted in the exhibition catalogue *Winifred Nicholson: Paintings 1900–1978* (Third Eye Centre, Glasgow, 1979).

92 *Sandpipers, Alnmouth*, $20\frac{1}{4} \times 25\frac{5}{8}$ (51.5 × 65). Private Collection.

OLSSON, Julius 1864–1942
Julius Olsson was born in London and had no formal art training. He moved to St Ives as a young man and remained there for twenty years, first exhibiting at the Royal Academy in 1890. Coastal scenery, often shown under stormy conditions, was his speciality. He moved back to London around 1911, when the Tate Gallery acquired his *Moonlit Bay*.

91 *Dunluce Castle, Northern Ireland*. Poster advertising the London Midland and Scottish Railway Company, 40 × 50 (101.6 × 127). National Railway Museum, York.

PASMORE, Victor b.1908
Victor Pasmore was educated at Harrow School, where he was encouraged to paint by his art masters. Owing to the early death of his father, he took up a job immediately on leaving school. Until 1938 he was employed in the Public Health

Department at County Hall in London. In the evenings he studied art at the Central School of Arts and Crafts, where his principal teacher was A. S. Hartrick. In 1933 he joined the London Artists' Association, through which he met William Coldstream and Claude Rogers. In 1937, with Rogers and Coldstream, he founded what was to become known as the Euston Road School, which stressed the value of objective attention to the model. In 1938 the patronage of Sir Kenneth Clark enabled him to become a full-time painter. Like David Jones he admired Bonnard, but he was also influenced by Sickert's orderly manner, and in the 1940s Ingres, Courbet, the Douanier Rousseau, Cézanne and Gauguin all interested him. From 1942 he and his wife lived at Chiswick Mall, where he painted a number of river scenes. In 1947 he moved to Blackheath, at which time he was beginning to experiment with abstract patterning in landscape contexts. During the early 1950s he became a leading influence in English Constructivism, and undertook a number of public projects, such as a spiral mural for the South Bank Regatta Restaurant in 1951. He developed the idea of Basic Form, which involved a break with representation and two-dimensional painting. As a consequence he became a maker of reliefs, and also one of the most influential art educators of the 1950s. His career is surveyed by Roland Alley in an exhibition catalogue, *Victor Pasmore* (Tate Gallery, London, 1965).

104 *Beach in Cornwall*, $10\frac{1}{4} \times 12\frac{3}{4}$ (26 × 32.4). The Arts Council of Great Britain, London.

113 *The Quiet River: The Thames at Chiswick*, 30 × 40 (76.2 × 101.6). The Tate Gallery, London.

PATRICK, James McIntosh b.1907
McIntosh Patrick studied at Glasgow School of Art between 1924 and 1928 but has otherwise lived in Dundee all his life, with the exception of war service in North Africa and Italy. The bulk of his work features Eskdale in the region of Angus, painted out of doors in all weathers. His very detailed paintings were well received when they began to be exhibited in the early 1930s. During the 1920s he was also active as an etcher, of Scottish and French subjects. The area featured in *Autumn, Kinnordy* is in Angus, inland from Dundee.

45 *Winter in Angus*, $29\frac{3}{4} \times 40$ (75.6 × 101.6). The Tate Gallery, London.

63 *Autumn, Kinnordy*, $30\frac{1}{4} \times 40\frac{1}{4}$ (76.8 × 102.2). Dundee Museums and Art Galleries.

PELLEW-HARVEY, Claughton 1890–1966
Brought up in Blackheath, London, Pellew-Harvey studied at the Slade School of Fine Art, where he was a contemporary of Paul Nash. Paul Nash, in his autobiography *Outline* (London, 1949), describes Pellew-Harvey as an important influence: 'I found he had a deep love for the country, particularly for certain of its features,

such as ricks and stooks of corn. At first I was unable to understand an almost devotional approach to a hay stack, and listened doubtfully to a rhapsody on the beauty of its form.'

35 *Embankment at Night*, $17\frac{3}{4} \times 23\frac{5}{8}$ (45 × 60). Hove Museum of Art.

PIPER, John b.1903
At the age of twenty-five John Piper decided to abandon his work in the law and become an artist. He attended several art schools, finishing at the Slade School of Fine Art in 1930. From childhood onwards he was interested in architecture: church architecture at first, and then in the early 1930s the lighthouses, piers and harbours of the south coast. After a period as a Constructivist sculptor and an abstract painter he began to make and to exhibit collages and to take pictures of Welsh Nonconformist chapels with which he illustrated articles in *Architectural Review* and *Country Life*. In 1938 he produced *The Shell Guide to Oxfordshire*, and first began to search out and to paint 'stained glass, churches with box-pews in a Cotman state of picturesque decay, ruins, early industrial scenery, Welsh lakes and waterfalls, follies, country houses, Yorkshire caves'. His work of the 1930s and 1940s is gracefully described by John Betjeman in *John Piper* (London, 1944) and examined in detail by David Fraser Jenkins in the exhibition catalogue *John Piper* (Tate Gallery, London, 1983).

75 *Portland, the Top of the Quarry*, $12\frac{3}{4} \times 20\frac{5}{8}$ (32.5 × 52.5). Towner Art Gallery, Eastbourne.

76 *Up the Gorge, Hafod, North Wales*, $21\frac{3}{4} \times 16$ (55.2 × 40.6). Victoria and Albert Museum, London.

PITCHFORTH, Roland Vivian 1895–1982
Pitchforth studied at Wakefield and Leeds Schools of Art and at the Royal College of Art after serving in the Great War. He taught life drawing for many years, at St Martin's, Camberwell and Chelsea Schools of Art. Of *Night Transport* he wrote in 1955: 'I had been interested in this type of subject for about three years previously and had done odd pictures from notes made during return visits from the coast by car, going out many evenings under similar conditions observing lorries and petrol wagons, etc. which fixed the conception.'

89 *Night Transport*, 20 × 30 (50.8 × 76.2). The Tate Gallery, London.

101 *Gliding*, 30 × 40 (76.2 × 101.6). The Arts Council of Great Britain, London.

RAVERAT, Gwendolen Mary 1885–1957
Gwen Raverat was the daughter of Sir George Darwin, Professor of Astronomy, and granddaughter of Charles Darwin. She studied painting at the Slade School of Fine Art from around 1908 to 1910. She was taught wood engraving by her cousin, the illustrator Elinor Monsell, and her first illustrations were for *Spring Morning* (London, 1915), by Frances Cornford, also her cousin. She lived in France during the Great War, but after the death of her husband returned to England in 1925. Her simple, vigorous style is comparable to that of such 7 & 5 Society painters as Wood, Morris and the Nicholsons in the late 1920s. Her style was influenced by that of Thomas Bewick: 'It was here, at No. 31 [Kensington Square], that I discovered Bewick, one afternoon while Aunt Etty was having her rest.' In 1949 she illustrated Trollope's Barsetshire in an anthology compiled by L. Tingay, *The Bedside Barsetshire* (London): 'yet when men, in distant corners of the world, think longingly of home and England, they dream of Barsetshire. They recall its homely cottages, its great houses, its leafy woods and narrow lanes.' Her early days are recalled in *Period Piece: A Cambridge Childhood* (London, 1952).

52 Woodcut from Frances Cornford, *Mountains and Molehills* (Cambridge, 1934).

RAVILIOUS, Eric 1903–42
Ravilious was born in Acton and brought up in Eastbourne. He studied at the Eastbourne School of Art from 1919. In 1922 he entered the Design School of the Royal College of Art to take a diploma in book illustration, and there met Edward Bawden and Douglas Percy Bliss. His instructors included Paul Nash and E. W. Tristram, the restorer of medieval murals, who interested Ravilious in mural painting; during the late 1920s and 1930s Ravilious executed several major commissions. In 1925 he became a member of the Society of Wood-Engravers. He began to teach in Eastbourne School of Art in 1925, where he interested his students in the writings of W. H. Hudson, Richard Jefferies and Gilbert White. In 1930, wanting to do more landscape painting, he and Bawden rented the Brick House at Great Bardfield in Essex. The artists eventually took the whole house and moved their families there in 1932. In 1934 the Brick House group began to visit the painter Peggy Angus in her cottage near Glynde in Sussex, and Ravilious responded enthusiastically to the Sussex landscape around Lewes. He illustrated numerous books during the 1930s, including *Poems by Thomas Hennell* in 1936 and Gilbert White's *Natural History of Selborne* in 1938. He became an official war artist in 1940, and in 1942 went on an air-sea rescue mission in Iceland, from which he never returned. A charming account of Ravilious and friends is given by Helen Binyon in *Eric Ravilious, Memoir of an Artist* (London, 1983).

p. 16 Wood engraving from Martin Armstrong, *Fifty-four Conceits* (London, 1933), $2\frac{1}{2} \times 2\frac{1}{4}$ (6.5 × 5.7). Victoria and Albert Museum, London.

56 *Train Landscape*, $17\frac{1}{2} \times 21\frac{1}{2}$ (44.5 × 54.6). Aberdeen Art Gallery and Museums.

79 *Cement Works, No. 2*, $19\frac{1}{8} \times 25\frac{1}{8}$ (48.6 × 63.8). Sheffield City Art Galleries.

110 Head-piece for 'January'. Wood engraving from N. Breton, *The Twelve Moneths* (London, 1927), $1\frac{1}{2} \times 4$ (3.8 × 10.2). Victoria and Albert Museum, London.

117 Wood engraving from Martin Armstrong, *Fifty-four Conceits* (London, 1933), $2\frac{1}{2} \times 3\frac{1}{8}$ (6.5 × 7.8). Towner Art Gallery, Eastbourne.

125 Wood engraving from *The Writings of Gilbert White of Selborne* (London, 1938), $2\frac{3}{4} \times 3\frac{7}{8}$ (7.1 × 10). Victoria and Albert Museum, London.

ROWNTREE, Kenneth b.1915
Rowntree studied at the Ruskin School of Drawing under Albert Rutherston and then at the Slade School of Fine Art under Randolph Schwabe. In the 1940s he was active as a muralist and as a landscape painter. In 1948 twenty-two of his watercolours were reproduced in the King Penguin book *A Prospect of Wales*, with a text by Gwyn Jones. His view of Wales was of a landscape heavily fenced, walled, inscribed and built over. After teaching at the Royal College of Art and working as Art Director for Shell, he became Professor of Fine Art at King's College, University of Durham, in 1959.

48 *The White House, Torcross*, $14\frac{3}{4} \times 20$ (37.5 × 50.8). The Arts Council of Great Britain, London.

ROYLE, Stanley 1888–1961
Born at Stalybridge, Royle attended the Sheffield College of Art. He was a successful painter during the 1920s, and a member of the Royal Society of British Artists. In 1931 he went to the Nova Scotia College of Art in Canada. He returned to England just before the Second World War, and settled at Worksop.

54 *Morning on the Derbyshire Moors*, 24 × 29 (61 × 73.7). Sheffield City Art Galleries.

SCHWABE, Randolph 1885–1948
The son of a Manchester merchant, Schwabe studied art at the Slade School of Fine Art under Alphonse Legros. He taught drawing at the Royal College of Art, and in 1930 was appointed Slade Professor in succession to Henry Tonks. Known generally for his drawings of landscapes and figure subjects reinforced with washes in monochrome, he became particularly interested in atmospheric effects towards the end of his life. He illustrated books by Edmund Blunden, Walter de la Mare, Arthur Symons and James E. Flecker. For examples of his work in context, see *The Artist's London, As Seen in Eighty Contemporary Pictures* (London, 1924).

85 *Dover*, $10\frac{1}{4} \times 10\frac{3}{4}$ (26 × 27.3). Collection: Dover Museum. Photo courtesy of The Fine Art Society, London.

SEAGO, Edward Brian 1910–74

Seago was born in Norwich and trained by the East Anglian naturalist painter Bertram Priestman. By 1929 he was exhibiting and selling equestrian paintings in Bond Street. Between 1930 and 1933 he travelled around Britain and Europe with circuses, and published *Circus Company* (London, 1933), with an introduction by John Masefield. In the 1940s he was described by Field-Marshal Lord Alexander of Tunis as 'the most promising English landscape painter of his generation'. In *A Canvas to Cover* (London, 1947), Seago shows himself worried by contemporary estrangement from the land, which had become for most people 'a landscape panorama seen in passing'.

98 *Evening Haze, Thurne Dyke*, $8\frac{1}{2} \times 10\frac{1}{2}$ (21.6 × 26.7). Norfolk Museums Service (Norwich Castle Museum).

SMITH, Edwin 1912–71

Although trained as an architect, Edwin Smith worked mainly as a photographer of architecture and landscape. With his wife, Olive Cook, he was a regular contributor to *The Saturday Book* during the 1940s and 1950s, specializing in Pop Art subjects and in Victorian *art populaire*. He was the author, with Graham Hutton, of *English Parish Churches* (London, 1952) and, with Olive Cook, of *English Cottages and Farmhouses* (London, 1954). He collaborated with G. S. Fraser on *Scotland* (London, 1955), with Geoffrey Grigson on *England* (1957) and with Edward Hyams on *The English Garden* (1964).

105 *Derbyshire, near Sparrowpit*. Edwin Smith.

133 *Chatsworth, from the Main Terrace*. Edwin Smith.

SOUTHALL, Joseph Edward 1861–1944

Southall was born in Nottingham of Quaker parents and in 1878 was articled to a major firm of Birmingham architects. In 1883 he visited Italy and as a result of reading Ruskin's *St Mark's Rest* and seeing Carpaccio's *Life of St Ursula* series in Venice decided to paint in tempera, seeking advice from Charles Eastlake's *Materials for a History of Oil Painting*. In 1901 he was one of the founder members of the Society of Painters in Tempera. He demonstrated this technique at Birmingham School of Art, and privately to other artists, including Ethelbert White. In 1906 he toured in Italy with Charles Gere and his sister. With them, Gaskin, Sleigh and others, he formed the Birmingham Group of Artist-Craftsmen, which exhibited for the first time in 1907 at the Fine Art Society. He sought to build up his pictures with 'spaces of bright colour', delicately but firmly outlined. He abandoned the use of shading and used an underpaint of raw sienna to create a golden tone throughout. His picture of *A Cornish Haven* shows the Fowey Estuary, seen from a promontory above Ready Money Beach.

towards Polruan – one of his favourite sites. George Breeze gives many details of his career in an exhibition catalogue, *Joseph Southall 1861–1944: Artist-Craftsman* (Birmingham Museums and Art Gallery, 1980).

40 *A Cornish Haven*, $11\frac{3}{8} \times 9$ (29 × 23). Courtesy The Trustees of the Royal Society of Painters in Water-Colours, London. Photo A. C. Cooper.

SPENCER, Gilbert 1892–1979

Spencer was born at Cookham in Berkshire and after attending the Ruskin School at Maidenhead went, in 1911, to the Camberwell School of Arts and Crafts, and to the Slade School of Fine Art between 1913 and 1915. From 1932 he was Professor of Painting at the Royal College of Art, and from 1948 he was Head of Painting at Glasgow School of Art. In 1920 he and his brother Stanley stayed with the painter Henry Lamb at Stourpaine in Dorset, and he returned there often. In the 1930s he rented a Dorset farmhouse and illustrated books by the Dorset writer T. F. Powys: *Fables* (London, 1929) and *Kindness in a Corner* (London, 1930). *Cotswold Farm*, begun in Hampstead in 1930 and finished in Ladbroke Grove in 1931, is one of his best known paintings. He described it as 'entirely imaginary and no studies or drawings were made from nature for it. This would explain a number of things in it that are not Cotswold in character. I have often used agricultural settings, mostly secondary in which to place my designs.' He wrote an autobiography, *Memoirs of a Painter* (London, 1974): 'Country sounds going on all round me put me in a happy mood, and got into my pictures.'

27 *Winter Landscape*, $17\frac{5}{8} \times 22\frac{1}{2}$ (44.8 × 57). Victoria and Albert Museum, London.

71 *A Cotswold Farm*, $55\frac{1}{2} \times 72\frac{1}{2}$ (141 × 184). The Tate Gallery, London.

121 *Melbury Beacon*, 24 × 36 (61 × 91.5). Southampton Art Gallery.

SPENCER, Sir Stanley 1891–1959

Born at Cookham in Berkshire, Stanley Spencer was the eighth child of an organist and piano teacher. He entered the Slade School of Fine Art in 1908, where his contemporaries included David Bomberg, Paul Nash and Edward Wadsworth. In 1920 he painted landscapes in Dorset while staying at Durweston with his brother Gilbert; these were at once the outcome of an attempt to escape from 'war depression' and the result of rivalry with his brother, although he also thought they might find a market. At Wangford in Suffolk he painted 'the finest landscape I ever enjoyed painting. . . . a wandering marsh land but full of character'. Painted in 1924, this was the first of his panoramic landscapes. In 1926 he was commissioned by Chatto and Windus to provide twenty-five illustrations for an *Almanac*. He married Anne Hilda Carline in 1925. Between

1927 and 1932 he worked on the Sandham Memorial Chapel at Burghclere in Hampshire. During the 1930s he painted many landscapes and garden pictures, partly because of the high prices they commanded. Many biographical details appear in Keith Bell's exhibition catalogue, *Stanley Spencer R.A.* (Royal Academy of Art, London, 1980).

68 *Rickett's Farm, Cookham Dean*, 26 × 46 (66 × 116.8). The Tate Gallery, London.

126 *Tree and Chicken Coops, Wangford*, 18 × 30 (45.7 × 76.2). The Tate Gallery, London.

SQUIRRELL, Leonard Russell 1895–1979

Born in Ipswich, Squirrel studied at Ipswich School of Art and at the Slade School of Fine Art. He was an etcher, illustrator and landscape artist whose orderly manner sometimes recalls that of J. S. Cotman. In 1925 and 1930 he won gold medals at the International Print Makers' Exhibition at Los Angeles. The subjects of his etchings and aquatints were picturesque sites mainly in Britain, but also in France. He was the author of *Landscape Painting in Pastel* (London, 1938) and *Practice in Watercolour* (London, 1950). His career is surveyed by Josephine Walpole in *A Biographical Scrapbook* (Woodbridge, 1982).

43 *A Dovedale Gorge*, $10\frac{1}{2} \times 16\frac{1}{8}$ (26.8 × 41). Ipswich Museums and Galleries.

SUMNER, George Heywood 1853–1940

Sumner was born at Alresford, Hampshire, into a clerical family and was educated at Eton and at Christ Church, Oxford. He qualified as a barrister but became a leading member of the Arts and Crafts Movement in the 1880s. For reasons of ill health, he withdrew to rural Hampshire in the late 1880s and turned his attention increasingly to local history and archaeology. He wrote and illustrated many books on the New Forest area, ranging from detailed accounts of archaeological sites to *A Guide to the New Forest* (Ringwood, 1924). His greatest celebration of that area is his tapestry design of 1908, *The Chace*, which features an archaic hunting scene among beech trees and heather (Hampshire County Museum Service, Winchester).

94 *Stonehenge*, $4 \times 11\frac{3}{8}$ (10 × 29). Salisbury and South Wiltshire Museum.

124 *The Road Through Mark Ash*. Illustration from Heywood Sumner, *A Guide to the New Forest* (Ringwood, 1924).

SUTHERLAND, Graham 1903–80

Brought up in Surrey and Sussex with holidays in Swanage, Sutherland was to have been an engineer and in 1920 was apprenticed in the Midland Railway Works at Derby. For the next five years he studied at Goldsmiths' School of Art, specializing in etching. From Goldsmiths' he

travelled out to work in the Arundel area in Sussex. Between 1923 and 1929 he exhibited etchings annually at the Royal Academy of Art. In 1926 he became a Roman Catholic, and in 1927 married and moved to Kent. He paid annual visits to Dorset, and from 1934 onwards began to visit Pembrokeshire. During the 1930s he designed posters for the Shell Company, the Orient Line and for London Transport, as well as designing china, glass and fabrics. Like other artists from Goldsmiths he was influenced by Blake and Palmer towards a dark, visionary style of landscape. He attributed his manner to the Pembrokeshire countryside: 'It seemed impossible here for me to sit down and make finished paintings "from Nature". Indeed, there were no ready-made subjects to paint. The spaces and concentrations of this clearly constructed land were stuff for storing in the mind. Their essence was intellectual and emotional, if I may say so. I found that I could express what I felt only by paraphrasing what I saw.' (From a letter to Colin Anderson.) In 1947 he was assessed by Robin Ironside as a painter 'of mainly uninhabited landscape; but his mountains burning at sundown are the theatre of human passions and his woods are the womb of human impulses; and the grotesque bifurcation of the dead or dying tree-trunk which, in the first phase of his maturity, was the symbol of his predilection, seems to lay a disturbing stress on the insecurity of a faithless generation.' For an energetic account of his career, see Edward Sackville-West, *Graham Sutherland* (London, 1943).

4 *The Sluice Gate*, 5½ × 5¼ (14 × 13.4). Victoria and Albert Museum, London.

12 *Cottage in Dorset*, 5½ × 7 (14 × 17.7). Victoria and Albert Museum, London.

90 *The Dark Hill (Landscape with Hedges and Fields)*, 19¼ × 27½ (49 × 70). Swindon Permanent Art Collection, Borough of Thamesdown.

TANNER, Robin b.1904

Tanner's interest in etching and in black and white illustration grew from a childhood interest in Gustave Doré's steel engravings for the Bible. He trained at Goldsmiths' School of Art, where his instructor was Stanley Anderson. Anderson was outraged by what he called 'this blasted searchlight' in *Martin's Hovel*. This was based on an open hovel or shed he had seen in a farmyard at Allington, near Chippenham in Wiltshire, combined with details of a graveyard and church from Biddestone and a bramble-covered gate from Upper Castle Combe. In South London he felt 'homesickness and love for the grey stone farms and white lanes of home.' He was deeply impressed by the work of F. L. Griggs which he saw at exhibitions of the Royal Society of Painter-Etchers, and by the exhibition *Drawings, Etchings, and Woodcuts by Samuel Palmer and Other*

Disciples of William Blake at the Victoria and Albert Museum late in 1926. He made a number of distinguished etchings of Wiltshire subjects during the 1920s and in the early 1930s. In the 1930s he lived mostly in Wiltshire, 'in this small enclosed landscape'. In 1939 he contributed a number of illustrations to Heather Tanner's *Wiltshire Village*, an account of Kington Borel, an epitome of a village in north-west Wiltshire: 'To call back yesterday would be foolish even were it possible; but in order that what was noble in yesterday that still lingers might not pass unhonoured and unlamented this book has been made'. (From Heather Tanner's introduction to *Wiltshire Village*, London, 1939.) For details of his life and work, see Robin Tanner's *The Etcher's Craft* (Bristol, 1980).

118 *Martin's Hovel*, 6½ × 8⅜ (16.5 × 21.3). Garton and Cooke, London.

TAYLOR, Fred 1875–1963 X

Taylor was a prolific poster artist from about 1908 until the 1940s. In *Commercial Art* in 1926 his holiday posters were assessed thus by R. P. Gossop: 'So far as topographical accuracy is concerned no one, I imagine, has ever equalled Fred Taylor. His rendering of places will satisfy both the archaeologist and the architect. And he can enliven his scenes with people of the present day, folk such as we are likely to meet when holidaying.' He first came to attention in 1908 with a poster for the London Passenger Transport Board's *Book to Hampstead or Golders Green Fair*, an aerial view of a seething fairground, and also worked for a number of railway companies and for the Empire Marketing Board.

14 *Hampstead, London Memories*. Poster advertising the London Underground Railways, 40 × 25 (101.6 × 63.5). London Transport Executive.

TOWNSEND, William 1909–73

Townsend's childhood interests lay in nature and architecture. As a child he lived in London and spent his weekends walking in the countryside of East Kent. In 1926 he went to the Slade School of Fine Art, and then travelled in Egypt, France, Italy and Tunisia. During the 1930s he lived in Canterbury and worked on book illustration and jacket design; in these years he was also involved in left-wing politics. He continued to paint, and was associated with such Euston Road School painters as Victor Pasmore and William Coldstream. After the war he taught for William Johnstone at Camberwell School of Arts and Crafts, and then at the Slade. Throughout most of his life he kept a detailed journal, sections of which were edited by Andrew Forge and published as *The Townsend Journals: An Artist's Record of his Times 1928–51* (London, 1976). His several paintings of hop alleys were done at Rolvenden in Kent in 1950–51. They are attempts at construction, free from effects of light, and can

be compared to Victor Pasmore's images of spiral motifs from the same period.

64 *The Hop Garden*, 25 × 30 (63.5 × 76.2). The Arts Council of Great Britain, London.

TREVELYAN, Julian b.1910

Julian Trevelyan, the son of the historian R. C. Trevelyan, read English at Cambridge where he was introduced to modern painting by Humphrey Jennings, who was to become a major film maker in the late 1930s. On leaving Cambridge in 1931 he moved to Paris to study art. These days are recalled in an autobiography, *Indigo Days* (London, 1957), in which he suggests that his true art was shaped during a childhood in which he made 'drawings of imaginary cities, vast railway stations, and valleys full of smoking chimneys'. Art education diverted him from his proper path, which he rediscovered, almost by accident, while staying briefly in the Potteries in 1937: 'The concentration of smoking kilns, like so many monstrous bottles, the canals, the gaping chasms from which the clay had been extracted – all these produced in my mind a ferment of ideas and I drew like one possessed.' From 1935 onwards he lived at Durham Wharf, Hammersmith, 'close to the elements'. In 1937 he worked with the anthropologist Tom Harrisson and the poet Charles Madge on the Mass Observation project in Bolton, and during the war was involved in camouflage, disguising 'pill boxes as Cornish cottages and garages, public lavatories, cafés and chicken houses and romantic ruins'. Before the war he was also a member of the English Surrealist Group.

88 *The Potteries*, 21 × 26 (53.3 × 66). Swindon Museum and Art Gallery. Photo Courtauld Institute, London.

TUNNARD, John 1900–71

Born in Bedfordshire, John Tunnard was the son of a sporting painter and country gentleman. Between 1919 and 1923 he was a design student at the Royal College of Art. As a boy he lodged, during holidays, with a gamekeeper in Lincolnshire and developed a considerable interest in the wild life of the area. During the 1920s he was a designer for a number of textile manufacturers, and he only became a painter in 1929. In 1933, after his first one-man show at the Redfern Gallery, he and his wife bought a caravan and went to live at Cadgwith, a small fishing village on the eastern side of the Lizard peninsula in Cornwall. He set up a hand-block silk-printing business, and during the 1930s turned from figurative painting to abstraction. His work was influenced by Miró, Klee and Moore, and was included in Surrealist exhibitions in the late 1930s. Other influences were Gabo and the Constructivists; he was described in 1939 as 'the Heath Robinson of the Constructivists'. In an interview of 1944 he described his progress as a landscape painter as a move from an interest in

'literary dramatic content' to 'the geometrically dramatic content ... the dramatic movements of roads, of ruts sweeping into farmyards, of the lines of telegraph poles or the sweep of railings, and these I found myself exaggerating to get the geometrically dramatic.' This led to invention and to non-representational painting. His career is surveyed by Mark Glazebrook in an exhibition catalogue, *John Tunnard* (The Arts Council of Great Britain, London, 1977).

84 *Morrah*, $10\frac{3}{4} \times 15\frac{3}{8}$ (27.3 × 39). The Fine Art Society, London.

119 *Cornwall*, $17\frac{3}{4} \times 26$ (45.2 × 65.9). The Arts Council of Great Britain, London.

WADSWORTH, Edward Alexander 1889–1949
Born at Cleckheaton, Yorkshire, Edward Wadsworth was educated at Fettes College, Edinburgh. He trained as an engineering draughtsman in Munich, but returned to England in 1910 to go to the Slade School of Fine Art, where in 1911 he won the first prize for figure painting. In the same year he exhibited at the New English Art Club. He was also associated with the Rebel Art Centre of Wyndham Lewis. As an official war artist he painted pictures of camouflaged ships for the Canadian War Memorial. In 1920, his drawings of the Black Country were shown at the Leicester Galleries, and a selection published in the same year with an introduction by Arnold Bennett. In the early 1930s his style became more abstract. In 1933 he joined Unit One, but afterwards returned to figurative painting. Marine subjects remained his principal interest, although Wyndham Lewis considered him 'a genius of industrial England (deflected, so I think, into nautical channels)'.

23 *Roofs and Bridges*, $9\frac{7}{8} \times 15\frac{3}{8}$ (25 × 39). Victoria and Albert Museum, London.

86 *Black Country*, $13 \times 19\frac{5}{8}$ (33 × 50). The British Council, London.

WALLIS, Alfred 1855–1942
Alfred Wallis was born at Devonport, near Plymouth, and brought up in the Scilly Isles. After spending a number of years as a fisherman, he worked in the rag-and-bone trade for a while. When that declined he withdrew into himself, and kept company only with his wife, his newspapers and his Bible. His wife died in 1922 and at the age of seventy he took up painting 'for company', and for the next seventeen years painted on pieces of old card, got from a nearby grocer. In a note of 1943 Ben Nicholson described his work thus: 'He used very few colours, and one associates with him some lively dark browns, shiny blacks, fierce greys, strange whites and a particularly pungent Cornish green.' His art had authority, and it confirmed Nicholson and Wood in their search for a new directness.

38 *St Ives*, $10\frac{1}{8} \times 15\frac{1}{8}$ (25.7 × 38.4). The Tate Gallery, London.

WARD, Leslie Moffat b.1888, fl.1916–40
A painter and etcher of English landscape and architecture, Ward is especially associated with Dorset and the West Country. The figure in Ward's woodcut is the Long Man at Wilmington in Sussex; it may represent Pol or Balder, the Sun God, pushing aside the doors of darkness.

97 *The Long Man on the Downs*, $11 \times 9\frac{1}{4}$ (28 × 23.5). Towner Art Gallery, Eastbourne.

WATSON, Harry 1871–1936
Born in Scarborough, Harry Watson studied at the Scarborough School of Art from 1884 to 1888. He went to the Royal College of Art, and then to Rome on a scholarship. In 1895 he won the Queen's prize for modelling from life at the National Art Training School. From 1913 he taught at the Regent Street Polytechnic in London, and was an active member of its Arts Club and Snooker Team. He painted woodlands and streams in Pembrokeshire, and lake and mountain landscapes in the Lledr Valley near Bettws-y-Coed; he also worked at Montreuil-sur-Mer. See 'Artists' Country', a special autumn number of *The Studio* (London, 1932).

42 *Holidays*, $41\frac{1}{2} \times 61$ (102.8 × 155). The City of Bristol Museum and Art Gallery. Photo The Bridgeman Art Library.

WEBB, Clifford 1895–1972
Webb was apprenticed to a firm of lithographers before serving in the First World War, when he painted in his spare time. From 1919 to 1922 he studied at the Westminster School of Art under Walter Bayes and Bernard Meninsky, where he also began wood engraving. He taught drawing and engraving at St Martin's School of Art for twenty years until 1965.

96 *Roman Wall*. Wood engraving from Thomas Balston, *English Wood-engraving, 1900–1950* (London, 1951). $6 \times 7\frac{1}{4}$ (15.2 × 18.4).

WEBB, Margaret fl.1930–40
In addition to her work on John Claridge's *The Country Calendar*, Margaret Webb also illustrated *Early English Recipes Selected from the Harleian Ms. 279* (London, 1937).

pp. 1, 97 Wood engravings from John Claridge, *The Country Calendar* (London, 1946).

WHISTLER, Rex John 1903–44
A brilliant and prolific painter, designer and illustrator, Whistler was one of the most fashionable artists of his time. He was educated at Haileybury, at the Slade School of Fine Art under Professor Tonks, and in Rome. In 1926–27 he worked on *The Pursuit of Rare Meats*, a mural decoration for the Tate Gallery. This established his reputation, and he subsequently decorated a number of rooms in private houses. For Sir Philip Sassoon he painted the Tent Room, installed at

Port Lympne in Kent, the famous house planned by Sir Herbert Baker just before the First World War. He was also a prolific book illustrator, examples of his work appearing in *Gulliver's Travels* (London, 1930), Walter de la Mare's *Desert Islands* (London, 1930) and *Lord Fish* (London, 1933). His country scenes decorate Beverley Nichols' enormously popular reports on country life: *Down the Garden Path* (London, 1932), *A Thatched Roof* (London, 1933) and *A Village in a Valley* (London, 1934). He designed posters for the London Passenger Transport Board, as well as for Shell, who published *The Vale of Aylesbury* in 1933. As a lieutenant in the Welsh Guards, he was killed in a tank action in Normandy.

p. 8 Illustration from Beverley Nichols, *A Village in a Valley* (London, 1934).

51 *The Vale of Aylesbury*, $39 \times 21\frac{1}{2}$ (99 × 54.6). By courtesy Shell UK Ltd.

WHITE, Ethelbert Basil 1891–1972
Ethelbert White was born at Isleworth in Middlesex, and between 1911 and 1912 studied at the St John's Wood School of Art. With C. R. W. Nevinson he experimented with Futurism. He was especially active as an illustrator and wood engraver, and between 1919 and 1921 designed and engraved covers, text decorations and endpapers for the Beaumont Press – including illustrations for Herbert Read's *Eclogues* (London, 1919). Using a bold, modern style of wood engraving, he illustrated Richard Jefferies, *The Story of My Heart* (London, 1923). He was appointed art editor of the Penguin 'Modern Classics' series in 1938, for which he illustrated Thoreau's *Walden* in the same year. His paintings and wood engravings show a regular swinging rhythm in landscape.

3 *Summer*, $36\frac{5}{8} \times 23$ (93 × 58.4). Design for a poster advertising the Underground Electric Railways Company of London, Ltd. Victoria and Albert Museum, London.

WILKINSON, Norman 1878–1971
Wilkinson was one of the most enterprising and successful of all commercial artists. In 1898 he began to draw for the *Illustrated London News*, and he soon gained fame as a painter of ships. From 1905 he was an innovative poster artist for the London North Western Region Company. During the Great War he reported on the Dardanelles campaign and invented dazzle camouflage. In 1924 he launched the scheme of London Midland Scottish posters by artists. His life story is told in *A Brush with Life* (London, 1969).

44 *The Trossachs*. Poster advertising the London Midland and Scottish Railway Company, 40×50 (101.6 × 127). National Railway Museum, York.

WILLIAMSON, Harold Sandys b.1892

Williamson was born in Leeds, and studied at the Leeds School of Art between 1911 and 1914 before moving to the Royal Academy School. A painter and a poster designer, he also served as Headmaster of the Chelsea Polytechnic between 1930 and 1958. He designed posters for the Empire Marketing Board, an organization set up in 1926 to create 'a background of interest in the subject of Empire buying', and also worked for the Post Office in 1934, and in the 1940s for the Council for the Encouragement of Music and the Arts.

66 *September Hop-picking*, 31 × 40½ (79 × 103). Amenities Department, Kettering Borough Council.

WOOD, Christopher 1901–30

Wood was born at Knowsley, near Liverpool, on the estate of the Earl of Derby where his father was the Earl's doctor. He attended Marlborough School until the age of fourteen when he contracted a serious blood disease. He studied architecture at Liverpool University where he met Augustus John, who encouraged his interest in art. Leaving Liverpool, he apprenticed himself to a fruit merchant in London, where he quickly became familiar with the clubs favoured by Augustus John. In 1921 he left for Paris, where he met the wealthy Chilean diplomat Antonio de Gandarillas who enrolled Wood in Parisian art schools. With Gandarillas he travelled widely in the Mediterranean between 1921 and 1926. In a letter to his mother in 1922 he claimed that the great modern painters were seeing 'through the eyes of the smallest child who sees nothing except those things which would strike him as being the

most important.' In Paris he was impressed and encouraged by Jean Cocteau, Picasso and Diaghilev. More influential still was his meeting with Ben and Winifred Nicholson on his return to London in 1926; with them he travelled to St Ives in the autumn and began to develop a simplified rather than a decorative manner. The painting reproduced here is one of his earliest in this style. He continued to draw strength from the austere life style of the Nicholsons and spent long periods with them in Cornwall and in Cumberland. In 1927 he exhibited with the 7 & 5 Society, of which Ben Nicholson was then chairman. In 1929 he went to Brittany, where he painted with the French Neo-Romantic Christian Bérard. Towards the end of his career he was admired, both in Britain and in France, as a mystic who could make colours 'sing'. In the 1920s he was a hedonist: 'Live for the present, not much for the future, and think you are going to live for ever. Then you may be happy'. His work is surveyed by Michael Mason in the exhibition catalogue *Christopher Wood* (Arts Council of Great Britain, London, 1979).

33 *China Dogs in a St Ives Window*, 25 × 30 (63.5 × 76.2). Private Collection.

WOODROFFE, Paul 1875–1954

Woodroffe was trained at the Slade School of Fine Art. Influenced by Laurence Housman and Walter Crane, he worked as a book illustrator. In the late 1890s he trained as a stained-glass designer, and in 1909 was commissioned to design fifteen windows for the Lady Chapel of St Patrick's Cathedral in New York. In 1904 he moved to Chipping Campden in the Cotswolds

and lived there for thirty years. In the 1920s he made several studies of local scenery, including one of trees on Dover's Hill, Chipping Campden, which forms the basis for his poster *Heaven's Gate*. Peter Cormack gives details of his career in the exhibition catalogue *Paul Woodroffe* (William Morris Gallery, London, 1982).

116 *Heaven's Gate Opens when the World's is Shut*. Design for a poster advertising the London General Omnibus Company. 40 × 25 (101.6 × 63.5). Victoria and Albert Museum, London.

WRIGHT, John Buckland 1897–1954

Born in New Zealand, Wright read history at Oxford and studied architecture at the Bartlett School in London University. In the mid 1920s, inspired by Gordon Craig's *Woodcuts and Some Words*, he taught himself wood engraving. From 1929 he worked in Paris at Stanley Hayter's studio. In 1936 he illustrated the first of his fifteen books for the Golden Cockerel Press. He specialized in erotic and Arcadian subjects and some of his idylls are comparable to those of Dunoyer de Segonzac.

p. 12 *Landscape with Figure*, 14 × 10 (35.6 × 25.4). The Arts Council of Great Britain, London.

The author and publishers are grateful to the following for permission to reproduce illustrations from their publications: B. T. Batsford Ltd, London 62; Cambridge University Press 52; Jonathan Cape Ltd, London pp. 8 (above), 9, 13; Harrap Ltd, London p. 11; Michael Joseph Ltd, London p. 8 (below).

INDEX

260135 21/5/85